WHAT ART IS LIKE,
IN CONSTANT REFERENCE TO THE ALICE BOOKS

WHAT ART IS LIKE,

in

CONSTANT REFERENCE

to the

ALICE BOOKS

———

Miguel Tamen

HARVARD UNIVERSITY PRESS
Cambridge, Massachusetts
London, England
2012

Copyright © 2012 by the President and Fellows of Harvard College
All rights reserved
Printed in the United States of America

Library of Congress Cataloging-in-Publication Data
Tamen, Miguel.
What art is like, in constant reference to the Alice books / Miguel Tamen.
pages cm
Includes bibliographical references and index.
ISBN 978-0-674-06706-6 (alk. paper)
1. Art—Philosophy. 2. Carroll, Lewis, 1832–1898. Alice's
adventures in Wonderland. 3. Carroll, Lewis, 1832–1898. Through
the looking-glass. 4. Alice (Fictitious character : Carroll) I. Title.
N70.T46 2012
701—dc23 2012010777

For Ana
For Madalena

Contents

"What are 'toves'?"

"Well 'toves' are something like badgers—they're something like lizards—and they're something like corkscrews."

"They must be very curious-looking creatures."

"They are that."

—LEWIS CARROLL, *Through the Looking-Glass, and What Alice Found There*

Introduction

WHAT TO EXPECT

This short book reacts to a prevailing mode of explaining art; according to that mode, art is to be explained by collecting opinions and definitions of art, summaries of philosophical claims, and critical judgments put forth by third parties. The purpose of this book, instead, is tentative and decent: to proffer a general sense of difficulties and to try to describe what art is like.

It is a reactionary book, and in two main ways. The first is that it only talks about a few problems and indirectly suggests that there are few general problems about art. Among these, attention is paid to the connection between art and having fuzzy ideas about art (Chapter 1), to the defense of the notion that art furniture is not art-specific (Chapter 2), to the mistake of imagining that art decisions are put forth by art-courts where you are both judge and jury (Chapter 3), and to the fuzzy, though essentially correct, idea that whatever happens with art must at least happen to you (Chapter 4). The second way in which this is a reactionary book is that instead of having its vocabulary derived from discussions within any given intellectual field, it suggests that those few problems can be adequately understood if one has read the Alice books. The Alice books are Lewis Carroll's *Alice's Adventures in Wonderland* (1865) and *Through the Looking-Glass, and What Alice Found There* (1871). A

great number of the technical words and phrases employed in what follows come from the Alice books, where of course most of them are never used in any technical way.

This may give some relief to those who feel daunted by the state of current discussions in the philosophy of art, aesthetics, and the various kinds of art criticism, including literary criticism. And still, while offering almost no opinions on art, the two Alice books surpass in difficulty and importance most such discussions. As the Alice books were written for seven-year-olds, this book also indirectly claims that any seven-year-old can acquire a sense of the few general problems there are about art. But since this book won't likely be read by seven-year-olds, the way it goes about its business should also be understood as a plea for a change in how grown-up audiences think about these matters.

Several disclaimers and warnings are in order. The first is that this is not a book *about* the Alice books. It is not a work in criticism, aiming to contribute to the vast secondary bibliography on the topic; nor is it about all forms of art or even any one art. It does not aim at any detached contemplation of a whole. No such detachment is available, possible or desirable. Rather, the book insists on the fact that talking about art should be seen as contiguous with talking about many other relevant and important things and, indeed, with many other human activities. It expresses the hope that if you know the Alice books well enough, you will be able to understand this point. If such hopes are well-founded, thus, the Alice books are, if not all you know on earth, at least all you might need to know in this case. And so you should read them or have read them before you begin reading this book. This book may not be secondary bibliography to the Alice books, but it is at all times second to them.

Someone once wrote a book "in constant reference to Socrates." The locution 'in constant reference' is a useful one. It denotes an attempt to do justice to a problem while at the same time realizing that you owe the very terms in which that problem will be described to certain readings, authors, people, or experiences, though not necessarily readings or authors or people who have addressed that problem. It may then be the case that how someone came to see the arts may owe much to the Alice books, which are in no discernable sense about the arts.

And so the only text directly quoted in this book is a critical edition of the two Alice books. All direct citations are identified in a separate index. For the purposes of the argument, the Alice books are one book and are treated co-

extensively and mixedly. This does not denote any lack of rigor but, rather, the ordinary way in which books that are taken very seriously are dealt with. Quoting not only *Proverbs* and *Luke, Pickwick* and *Little Dorrit,* and *Lear* and *Richard III* but also *Luke* and *Lear, Proverbs* and *Pickwick, and Dorrit* and *Alice* in one breath and as one book is a sign of that seriousness, a sign of how one's life has become strictly contiguous with such books as well as with many other things. Also, this is no custom entertained only by the philosophically inclined. It is how everyone goes about such matters.

Two final disclaimers are still required. The first has to do with the way in which this book was written, which to some will very much remind them of other books they may have already read. The book puts forth no claim to stylistic originality, let alone stylistic genius. However, even if it does not pretend to emulate such books, it may share with them at least a sense that a certain style, where remarks will often accumulate as arguments, is required in order to avoid the pitfalls of the usual contemplative genre. An important part of this book, then, consists in suggesting, tirelessly and perhaps tediously, a series of analogies and similes, many of which will only make sense in the context of their initial occurrence. The reader will notice that this often entails pointing to resemblances between otherwise very different things, words, or states of affairs, and the reader is encouraged to think through such intemperate analogies, and perhaps to think away from them, but also to think about them as they are developed rather than in any gnomic or splendid fragmentary way. A modicum of intemperateness appears to be required whenever we attempt to explain what something is *like.* The intemperateness often shows in hyphenated barbarisms such as 'judge-and-jury,' 'tart-in-court,' 'fish-quintet,' or 'so-around.' One last disclaimer concerns the loose sense in which most of the crucial words are employed in what follows. The reader will notice, and perhaps resent, that an implicit case is made for some of the most important words in the argument to be understood casually. Among others, this is the case of 'person,' 'stuff,' 'things,' 'talk,' 'about,' and, not least, 'like.' No apologies are offered, but in the interest of clarity an analytical table of contents is provided at the end of this book.

I

Ideas

(§§1–55)

§1. Alice comes across a book and remarks: "It's all in a language I don't know." Then she corrects herself: "Why, it's a Looking-glass book, of course! And if I hold it up to a glass, the words will all go the right way again." Many people believe that certain books, often poetry books, are, by definition, written in a foreign language. It is clear that they don't mean a language like Swedish. It is not clear, however, what they mean.

§2. When you say that a poem is written in a foreign language it's of no consolation that someone offers to translate it for you. That's not what you mean. You mean instead that your problem is not to be solved with the help of any dictionary or encyclopedia or translator or knowledgeable person. You mean that there are no native speakers to that poem. Humpty Dumpty, a mixture of all of the above, claims to be able to explain "all the poems that were ever invented— and a good many that haven't been invented just yet." Alice asks Humpty Dumpty questions like "What's to *'gyre'*?" or "What are *'toves'*?" She could have asked many more questions of course ('What is a Bandersnatch?'). When Alice is done asking, however, the poem remains as foreign as it was. And this is not because you suspect Humpty Dumpty is making up all the answers,

though you might. The words may have gone all the right way and you may still claim that the poem was written in a foreign language.

§3. No amount of help will absolutely preclude poems from being thought foreign at some point or another. This indicates that being an expert in poems or films or painting or music is not like knowing a language. There is no such thing as a language of poetry, or a language of art. You know things about poems but you are never in the position of the native speaker of a language relative to them, just like you see trees but you are never in the position of a native tree-seer.

§4. Perhaps in poems you describe as foreign words that are in unusual positions. Or perhaps there are some special words that only appear in those poems. Are certain colors reserved for painting? Are certain sound sequences inherently *musical?* In poems you frequently come across humdrum word sequences and humdrum words and you may still want to describe them as written in a foreign language. Humdrum words may often feel foreign. You cannot predict foreignness from any feature of words, images, or sounds, or their combinations. What you deem foreign can only be predicted after what you deem familiar.

§5. When Alice goes through the glass into the Looking-glass room she remarks that "what could be seen from the old room was quite common and uninteresting, but that all the rest was as different as possible." This seems to capture what you sometimes mean by 'foreign.' You may say that a poem is written in a foreign language despite the fact that what you see is common and uninteresting. Perhaps what you see is what you call 'familiar.' What you don't see you do not see. *That* you don't see you call foreign.

§6. When you say that a poem is written in a foreign language, you are admitting that you don't see certain things about it. These things you may suspect are really important. Some people talk about the foreign language of poetry, or the foreign language of art, like others talk about foreign products, or foreign cultures. They may mean 'foreign' as a term of diffidence. But if they call foreign whatever they can't see, they are only raising questions about their own vision. Others may mean 'foreign' as a compliment. But if they call foreign whatever they don't see, they are only paying a compliment to their own lack of vision.

§7. What you see is what you get. This means that you see what is familiar. If a poem is described as written in a foreign language, the implication is that you don't get that foreign language as you might get Swedish. Regardless of what you may suspect is hidden by your lack of vision, which may eventually prove to be wonderful, you only call poetry a foreign language because you don't get it, or don't get certain things about it. It is perfectly possible for someone to get what others don't. It doesn't make any sense to say that poems are unfamiliar *by definition*. Some people are familiar with many poems. Others earn a living by making poems familiar to people. And it should be possible for a poem, even for a whole art form, to become totally unfamiliar at a given time, like the broken-off part of an object found in the attic whose purpose or identification no one quite knows anymore.

§8. You often imagine poetry, and perhaps all art, to be a series of things (words, marks, noises, customs) some people don't completely get. But then how are you to explain that most call it wonderful, and that they use words such as 'foreign' as compliments? Why would anyone call their lack of understanding wonderful? If you don't get a joke, you don't call it wonderful.

§9. It is, however, also possible that getting a poem may be expressed by calling it foreign. What there is to be "seen" is the fact that you can never fully see it. It is possible as well to call it foreign so other people may believe you got it. 'Foreign' at times looks like an abbreviation of a longer sentence; at other times it is only an admission ticket. In this, 'foreign' is similar to 'humdrum.' Some people call poems humdrum to indicate that at some point in the past they did get them completely and also to indicate that there was something irreversible about getting them. For them, getting something is making it completely familiar. Others may use 'humdrum' to indicate that poems are, after all, no great thing, that is, once you get them.

§10. When 'foreign' is an abbreviation of a longer sentence, what would such a sentence look like? Alice spells out a possibility: "Somehow it seems to fill my head with ideas—only I don't know exactly what they are!" Whatever is in a language I don't know, or so Alice is saying, is the cause of fuzzy ideas. Hers is a doctrine about poetry and perhaps a doctrine about all arts. It defines a poem by what happens to those exposed to it. Those exposed to it get fuzzy ideas. They don't "get" the poem in any discernable sense. Perhaps what you

call wonderful is, after all, the fuzzy ideas you get, the fuzzy ideas you get instead of the poem, or perhaps poems are "gotten" only as fuzzy ideas. Of course, this makes it all sound like epidemiology without biochemistry, and it is a fuzzy idea in its own right.

§11. Fuzzy ideas are not necessarily false ideas or lesser ideas: time will tell. You walk in the streets of Stockholm and are bombarded by Swedish noises. You may believe the noises cause you to fill up with ideas. Or you attend some unfamiliar ceremony. You may believe that what you see fills you up with ideas. In either case you may have difficulty in describing those ideas. But from the fact that you have trouble describing ideas, it does not follow that they are always bad or unimportant. Nor, of course, does it follow that they are in any way good or important.

§12. It seems wrong to say that people, by definition, enjoy having fuzzy ideas. Some may, but that is beside the point. Alice, for one, "didn't like to confess, even to herself that she couldn't make it out at all." So Alice's remark is about the *connection* between not understanding a poem and getting fuzzy ideas from it. Fuzzy ideas are an unintended consequence of the impossibility to understand a poem in any clear way. This is a pessimistic doctrine, not because it suggests that fuzzy ideas are fuzzy but because it assumes poems are not for you or anyone to get.

§13. Still, Alice's doctrine leaves room for a number of different attitudes toward poems. Some may become used to not getting what they had thought they might get, and they thrive on it. Others may resent that what they always seem to get is the consequence of their not being able to get what they had originally wanted to get, namely, the poem. Alice appears to belong in the second group. She never quite manages to become familiar with poems; she is always disappointed with poems. "It is very pretty," she says about the *Jabberwocky,* "but it's *rather* hard to understand." You may suspect there is a connection between not "getting" a poem and calling it pretty and a connection between what you define as things pretty and what you define as things unfamiliar.

§14. Still, why would you call an incomprehensible poem pretty? This sounds like damning with faint praise. Alice's choice of words conceivably means

that 'pretty' is the sort of word we use to describe what we don't get. Perhaps 'pretty' is like a consolation prize, or a concession to politeness, a prize you award to the cause of your fuzzy ideas. Or perhaps Alice uses 'pretty' simply to indicate that she is not used to that particular poem.

§15. Words like 'pretty' and 'wonderful' are often employed by people about things that are unfamiliar to them. Just like 'foreign' can be a term of abuse, so 'pretty' may suggest that something is amiss. You don't normally use these words among people who claim to be familiar with a poem, nor to claim you are familiar with it. Professionals don't call poems pretty when they talk among themselves. When you use words such as 'pretty' or 'wonderful,' these words appear to be doing work for something else. They may be doing work for an explanation that will not be forthcoming. They may look like firm opinions, but they offer nothing in support of that impression.

§16. What would it be like to understand a poem? Alice suggests that understanding a poem is like understanding a kitten. Kittens are often pretty but also hard to understand. In fact, "it is a very inconvenient habit of kittens . . . that, whatever you say to them, they *always* purr. If they would only purr for 'yes,' and mew for 'no' or any rule of that sort . . . so that one could keep up a conversation! But how can you talk with a person if they *always* say the same thing?" There is a connection between feline behavior and the fact that Alice calls kittens "dear" and "pet." One suspects that such words may often be little more than the vocative case of 'foreign.'

§17. For Alice, poems are like kittens in yet another important related respect, and that is because you can't keep up a conversation with them. They don't talk back and indeed can't talk at all. Talk about poem language is often like talk about animal language. There also is a similarity between seeing feline purring as talk and seeing unfamiliar words as words. Like kittens, poems "*always* say the same thing"—regardless of the words. If so, that is not saying much of anything, since if your poem always says the same thing it becomes "impossible to guess whether it meant 'yes' or 'no.'"

§18. This is not just a predicament kittens share with poems. They also share it with music, films, paintings, and the rest. All art is like that. Its purring makes it very hard to guess what it says. Like kittens, but unlike music, poems are art

whose purring you describe as words. But purring is not just what kittens and poems do: think of nature, numbers, other minds, or the past. All of these may only purr, most fill our heads with ideas, and all have been sometimes described as foreign. If your primary concern is with what they may say to you, then you don't really need a separate doctrine about your interactions with poems any more than you need one about your interactions with kittens. Your interactions with nature, the past, numbers, other minds, and poems and kittens do not require separate explanations. They may require, however, that you describe what you mean by "getting" each of these things in each case, which could vary enormously. For instance, poems you try to "get" by identifying words; paintings you don't. Both purr and may be hard to understand.

§19. A doctrine about your commerce with poems, just like a doctrine about your commerce with kittens, would often be a doctrine about how to carry a conversation with a poem. These may be doctrines about hearing voices, sometimes about forms of perception, hearing aids, propitiatory exercises, familiarity, feelings, or ownership. A great number of people have claimed to have heard poems speak. A few people even claim to own a number of poems. One of the most standard things about such voices is that they all speak to you in languages you can understand. If you can't understand Swedish, you can be certain that your favorite poems will not purr back to you in Swedish, as certain as you are that the past will reveal itself to you in a language you understand. You may suspect the world would have been different had the meaning of the past revealed itself instead in unfamiliar tongues. And that is the point. The past speaks to you in your own tongue because the past has no tongue. The past is just like art.

§20. "We're all mad here," the Cheshire Cat purrs. If poems are like cats, and if all cats are like their Cheshire cousin says they are, are poems mad? They seem so a bit, since there do not appear to be "any rules in particular" that would allow us to guess what they mean. The purring you describe as words, but the actual words are always your own. And so poems would be likely incapable of meaning anything. But, again, calling them mad is like calling them foreign. They don't really have minds or bodies of their own out of which to be mad any more than they can hold passports. So poems, like kittens again, can't really be mad. They have not lost their reason any more than they have ever lost the use of language.

§21. A better question is this: Are people engaged in commerce with poems mad? There is no *general* reason they couldn't be. Surely some are. And you can certainly be *too* engaged with poems. When you are too engaged with poems, you begin not only to entertain funny ideas about them but, more importantly, to think that they are the source of those ideas in a special sense. Instead of describing your ideas as mere effects, you often entertain the notion that there is a hidden connection between causes, effects, and yourself. This is like saying that you lost your wallet because you had a flat tire while implying that there is something like a *deeper* link between these two occurrences, one that goes beyond them, as if even the lesser incidents in your life were the effects of divine concern. A sign that you may be too engaged with poems is when other people start reminding you that God might be engaged elsewhere.

§22. Though they are by no means the same, there seems to be a relation between imagining deeper links between poems and your ideas and imagining that you can carry a conversation with them. Those who don't see such links would sometimes behave toward you like they would toward people talking to themselves in the street or, indeed, toward people talking to animals. They might approach you with circumspection, like they would approach foreigners. Most would simply keep away and say it's none of their business. That you speak with poems may be thought to be a private matter entirely. And yet you might want to tell them that to you, to anyone who speaks with poems, speaking with poems is no private matter.

§23. People who are too used to a poem, who have been around a certain poem for a long time, people who believe they can hear what that poem has to say to them, often end up expecting help from it. Alice resorts to cats to solve problems of knowledge and perception. "Now, Kitty," says Alice, "let's consider who it was that dreamed it all . . . Oh Kitty, *do* help to settle it!" People unfamiliar with a given poem, on the other hand, often believe they need outside help with the poem. Help from a poem is like help from a cat, and this perhaps explains why you often believe you need help *with* poems. And you can certainly become *too* engaged with either kind of help.

§24. Outside help includes dictionaries, encyclopedias, translations, a secondary bibliography, and other people's opinions. And it may end up including

anything. When you worry about purring stuff, anything can be of help. Help *from* poems is more difficult to describe. Imagine an instruction manual attached to everything you call purring stuff, each poem, picture, photograph, or kitten. The manual would tell you how to approach it, and how to go about getting help from it. There is, of course, something almost amusing about the very idea of approaching a cat and, come to think of it, also about the idea of approaching a poem or approaching nature. How close is close?

§25. Some people would think of every poem as "a very small cake, on which the words "EAT ME" were beautifully marked in currants. 'Well, I'll eat it,'" said Alice. As they would. The question is not that of whether to trust a cake, of whether Alice's actions or anyone's actions are justified. The question is that cakes are incapable of being trusted. Of course, unlike Alice's cake, no purring entity comes with an obtrusive instruction manual. Perhaps, then, manuals are well-hidden. People conversant with such matters frequently suggest they know where they have been hidden. This is probably because they are always the ones who find them. Perhaps what you call the poem's instruction manual is typically brought about by trying to describe your own fuzzy ideas and attributing them to the poem in the process. Your own ideas you call instruction manual.

§26. Teaching things about art can be about persuading people to eschew outside help and look for concealed instruction manuals. It can be about teaching you to look for clues ("EAT ME"). Or it can be about suggesting that there is only outside help, about suggesting that if you want to know anything about a poem the only thing for you to do is to get acquainted with something not quite the poem. They suggest you trust information. And teaching things about art can also be about persuading people that there is a connection between outside help and instruction manuals, namely, persuading people that if you spend enough time around other people and dictionaries you will end up discovering the hidden instruction manual for every possible purring item. This is like saying that if you spend enough time around Humpty Dumpty, you'll end up seeing signs like "EAT ME."

§27. When people who have been around art too much start hearing voices, not only do those voices speak in their own language, and so those who hear them, in principle, require no outside help, but they speak to those who hear

them only about their own concerns or about themselves. This is why one does not usually overhear art (or, for that matter, kittens) any more than one hears them speaking in foreign languages. Just as poems never speak in a language you are not familiar with, so it appears you may never hear a poem in the process of speaking to someone else.

§28. Alice loses patience with the Red Queen and threatens her: "I'll shake you into a kitten, that I will!" While being shaken "the Red Queen made no resistance whatever." Why so? Well, because "it really *was* a kitten, after all." The Red Queen is like something Alice took for something nonpurring. This is like believing that chess pieces, poems, or playing cards can move and can talk, and talk back at you. However, this can't be completely right. After all, Alice "noticed several of the chessmen down in the hearth among the cinders; but in another moment, with a little 'Oh!' of surprise, she was down on her hands and knees watching them. The chessmen were walking about, two and two!" Immediately afterward, Alice overheard chess pieces talking in perfectly good English. There clearly is a connection between seeing chessmen move and overhearing the noises they make but also a connection between these two actions and the fact that those were English noises. Alice's little "Oh!" may look cousin to wonder, the beginning of all philosophy, but overhearing chess pieces talking in English is really not overhearing much of anything, and seeing them move is not seeing anything. There are no talking, moving chess pieces.

§29. And yet you can understand Alice's surprise, like you can understand people getting surprised at talking poems, talking cats, and inner voices but also becoming impatient when they see everyone around them talking to themselves in the street, addressing animals, poems, and so forth. Surprise and impatience come from a sense that other people are living another kind of life, a life unfamiliar to you. You may want to say that where you come from you do not expect poems to talk back, any more than you expect chess pieces to move, and that you don't listen to inner voices either. Insisting on where you are coming from, however, will only take you so far. It is not so much that it will prevent you from acquiring any notion of unfamiliar kinds of life, because after all it is never clear why you would want to do that. Rather, it would prevent you from seeing any activity carried out by anyone else as having anything to do with your own activities. The activities of people talking

to themselves in the street, addressing animals, or listening to poems would look more like choreographies or antics than like lives or actions. And so you would not consider the possibility of paying heed to their reasons, any more than you would pay heed to the reasons of a thunderstorm.

§30. Unlike the Cheshire Cat, for whom at least we are *all* mad, and so for whom perhaps no one really can be, by seeing other people's concerns as antics rather than actions you would be claiming that you are the only non-mad person in the world. If so, why bother with claiming? Confusing unfamiliar with mad is familiar, but imagining that all unfamiliar activities are mad is mad. An emphasis on humdrummery can also be a form of contemptuous madness, which is ultimately the madness of all emphasis on you. One other form of madness is claiming that nobody is coming from anywhere anyway, and so we are all foreigners to one another and unfamiliar to everything. Foreignness, indeed, may often breed contempt: " 'That's very important,' the King said, turning to the jury . . . '*Un*important, of course, I meant,' the King hastily said, and went on to himself in an undertone, 'important— unimportant—unimportant—important' as if he were trying which word sounded best." This form of madness consists in collapsing the distinction between what is familiar and what is foreign into the distinction between what matters and what doesn't. This is the sort of mad thing only a Cretan Cat would do.

§31. On the one hand, those who are not used to hearing certain voices may distrust art, which they may at best consider pretty foreignness, and they may oppose what to them is humdrum and familiar. But, on the other hand, to those who hear such voices, those who talk to them, those who expect help from them, and those who are familiar with them, art is what is humdrum. To cat people, distrusting cats may strike them as foreign. This is why explaining how you became familiar with a poem, how you developed that trust, and also perhaps how you might have lost that familiarity and trust is such a decisive business. At the same time, you sometimes wish there were good reasons for listening to purring voices *regardless*. A second, and even more important, business, then, is that of justifying the preferability of wherever you are coming from. Should you encourage art just because you wish to be surrounded by it? This second business should be attended only after realizing that such encouragements entail an extension of your expectations as to what

qualifies as your interlocutor, after realizing that you will have to admit cats and poems into the range of your possible interlocutors and learn all the intricate exercises that will foster and confirm your expectations.

§32. "Who cares for *you?*" Alice asks the Queen of Hearts. "You're nothing but a pack of cards!" There is little consolation in saying that poems are nothing but merely purring bits of stuff, that kittens can't talk back, and that the past does not come with an instruction manual, though these are all true. There is even less consolation in shedding crocodile tears over Alice's change of opinion about playing cards and calling it a loss. Alice, for one, doesn't see it as a loss. She appears to be rather tired of dealing with these hordes of inordinate interlocutors. She does not regret no longer being friends with the Queen of Hearts.

§33. For you to understand Alice's accusation you need to be able to understand that when she is claiming that the Queen and her friends are nothing but a pack of cards, she is also saying that she doesn't care about them. She doesn't mean that she now knows, owing perhaps to biology, or metaphysics, that queens are cards. She isn't imparting any piece of recently acquired knowledge, suggesting that it has come to her attention that the Queen and company are nothing but a pack of cards. She simply means that she is indifferent to anything relating to cards, for example, you could say you are indifferent to anything relative to a given province of purring stuff, say to art or cats. "Who cares for *you?*" In your repertory of expressions of distrust, few expressions are lower than accusing something of being *only* something else. When you do so, you mean you couldn't care *less* about that thing. Realizing that something or someone is "nothing but a pack of cards" is like realizing that all knowledge of it is, by definition, idle, and not like claiming to have acquired some new knowledge about that thing or person.

§34. If you cease to care in this sense for something or someone, you may also believe there are ways out of people, things, or activities. You may say 'I want my money back,' or 'I want a divorce,' or 'I will never do it again,' or 'I'll throw it out,' or 'I don't believe it anymore.' Of course, what you call ceasing to care is really a change of belief that may give you the impression of moving out of a life where certain beliefs you hold appear to require certain activities you engage in. How do you quit a belief? Alice wakes up and describes her

most recent life as "a curious dream." The implication seems to be that she couldn't care less about the contents of dreams. By describing it as a dream, she indicates that she couldn't care less for a certain kind of life ("Life, what is it but a dream?"). And you may come to see art, a person, or a belief as curious dreams and in the process reach the conclusion that you no longer care for them.

§35. Calling a dream "curious" is like calling a poem "pretty." In both cases you mean you don't really care. Both are claimed to be nothing but something else. Like 'pretty,' 'curious' suggests that no justification is forthcoming. The reason is that you don't care. When you say you don't care, no justification seems to be required. Only those who care would offer justifications, though of course justifications can do the work for all sorts of different opinions. This is why explanations of art are secreted and proffered only by those who care about art, whatever the form care takes, and theories about cats are put forth only by those who care about cats.

§36. Why should you care? It matters of course about what. Your reasons for caring about cats may be different from your reasons for caring about poems or the past. Despite the fact that poems can be described like cats, or like the past, it does not follow that your reasons for caring about each of these things are the same. So why should you care about poems? Not merely because some poems you find to be pretty, curious, or even wonderful. This is not answering the question yet, since words such as 'pretty,' 'curious,' or even 'wonderful' are used to discourage any further explanation in the first place and so offer no reasons. Perhaps it is because you like having fuzzy ideas and they are the *cause* of quite a few of those; thus you are inclined to honor the causes of things you like. But this would be like caring for your in-laws. Perhaps instead you care about poems because of this connection between dealing with poems in certain ways and expecting help from them.

§37. There are many similarities between forms of help you expect from poems and forms of help you expect from cats or from archaeological remains. This may have to do with the fact that they all tend to speak to you in your own language. Many people believe that examining the entrails of certain animals, even cats, will allow them to predict certain events. Many believe that examining certain archaeological remains will allow them to accurately

reconstruct certain events, events that have taken place in some very remote past. And there are many poem analogues to both the inspection of entrails and archaeology. Think of the emphasis on examination, the idea that you need to be able to look at poems in a certain way; or think about the idea that there is something as to how the various bits of what you define as a poem hang together. People who used to inspect animal entrails for divinatory purposes also believed animals had an author; the idea of hanging together often hangs together with the idea of an author. And there is the other idea that what has come to you matters because it has survived until it has come to you. This is essentially an idea about you and about how much you matter.

§38. The belief that poems talk to you about your own business is connected to the belief that poems can be used as evidence in matters that relate to your own concerns. If you could overhear poems you wouldn't be sure that they could ever be used as relevant evidence, since they could very well be talking to someone else, perhaps about someone else's concerns. It is therefore crucial that poems are talking to you and you alone. And help is always personal help, not because the same poem may not be found helpful by several, indeed many, people but in the sense that you may hire a personal trainer and, though the trainer may also have been also hired by other people, he is personal to you.

§39. Humpty Dumpty says that "When I make a word do a lot of work like that . . . I always pay it extra." He then imagines words coming round for their weekly wages. You may commend Humpty Dumpty's sense of justice and think that the help you get from poems is in some way reciprocated by actions that would show your care for them, though perhaps you would not go so far as paying them. It may seem that your concern for the survival of art and, indeed, your considerable investment in protecting art would constitute a form of reciprocation. However, talk of reciprocation is misleading. You do not keep a chair clean because you expect it to be comfortable to you in exchange, and there is something dubious even about the idea of being nice to people because they are nice to you.

§40. Perhaps, as in many other matters, talk of reciprocation, and the whole idea of a contract, is misplaced in relation to what art is like. The imagining of contractual agreements with poems and the rest is at one with the various conversational imaginings concerning purring stuff. It is not necessarily the

case that as soon as cats start talking back you immediately try to talk them into contracts of every kind. Certain preliminary difficulties persist. For one, you would not be able to find a remedy to a breach of contract with a poem. And this is not because poems cannot be prosecuted. Far more complex things, such as countries and corporations, may. The trouble is that you wouldn't know how to begin to see a poem's breach of contract as a crime. Although you may often expect help from poems, you wouldn't know how to find a legal remedy for any bad help you might get from them. The imagination of a contract with a poem seems instead to be like a description of the reasons you need that poem in the first place. The idea of paying your poems for the work they do for you is an expression of care rather than labor justice. It says more about how you live than about what they are or do. Indeed, what they are or do depends on how you live. And so perhaps you can detach evidence from justice at least as far as poems are concerned. The fact that you treat a poem as evidence is independent from your concern with the well-being of the poem and does not appear to require any form of reciprocation.

§41. A poem can be helpful as evidence in many ways. That a poem is evidence of something, some people would say, can be seen right away. Seen-right-away evidence is direct evidence. Evidence, however, is also said to require work, even outside help. The King of Hearts is hearing a case against the Knave of Hearts. The Knave, the prosecution claims, has stolen some tarts. A paper is found and brought to the attention of the court. "It's a set of verses." The verses are read. " 'That's the most important piece of evidence we've heard yet,' " said the King. At this point Alice interrupts: "If anyone can explain it . . . I'll give him sixpence. *I* don't believe there is an atom of meaning in it." The King looks relieved: "If there's no meaning in it . . . that saves a world of trouble, as we needn't try to find any." This is a disagreement about evidence. For Alice, evidence requires meaning and so explanation. For the King, it doesn't. When we believe in direct evidence, we also believe we have no need for outside help. You hear, or read, the poem, and that's that.

§42. The idea that poems offer immediate evidence saves you a world of trouble. It is akin to the idea that art is immediately relevant, relevant as a description of political circumstances, human nature, or animal behavior. Awkwardly, it is also akin to the idea that art is immediately relevant as a description of art. No special apparatus and no particular operations seem to be required for such

descriptions to emerge. And still it is curious that this idea often surfaces among people who, by virtue of being familiar with art, share similar explanations about it and see themselves as having developed a special apparatus of their own, and one that sets them apart from the humdrum. They have all undergone artistic education. Artistic education is frequently about forgetting that you had an artistic education, about coming to see art as offering immediate evidence. Also, just as the humdrum see certain things as foreign, those who have had a successful artistic education see the humdrum as foreign.

§43. Tweedledee repeats "The Walrus and the Carpenter," a poem featuring oyster-eating by the eponymous characters. "'I like the Walrus best,' said Alice, 'because he was a *little* sorry for the poor oysters.' 'He ate more than the Carpenter, though,' said Tweedledee . . . 'That was mean!' Alice said indignantly. 'Then I like the Carpenter best—if he didn't eat so many as the Walrus.' 'But he ate as many as he could get,' said Tweedledum. This was a puzzler." The puzzler might require some explanation. The explanation, however, would not be about what either Walrus or Carpenter *did*. The puzzle is intelligible as such and therefore only requires an explanation insofar as you see the poem as providing direct evidence about the actions of its characters. These are just like any old action. Alice, Tweedledum, and Tweedledee talk about the Walrus and the Carpenter as they would about any other assumed agent and, indeed, as *you* would talk about any assumed agent. You can have agents painted any color, as long as it is black. This is how we talk about characters, cats, real people, and even nature. That some people do not exist does not seem to affect the way we talk about them as agents.

§44. People who have been to poem school often behave as if talking about the actions of a character would require a change in how the character speaks, as if talking about the actions of a character would require scare quotes. They would say things like "Alice" 'asked' "a question." Their schooling is expressed by the quotes that may be designed to scare off other people. The quoting gesture is quite similar to a scaring gesture. The people they mean to scare off are people who have firm opinions about what the Carpenter did, who feel no special need to speak differently about the whole purring lot, poems, or cats, or the past. For them, books, paintings, or plays can be puzzlers (and so can cats, and so can the past), but there is never any difference between a puzzler and a "puzzler," as there is no relevant difference between the actions of a

talking walrus and those of existing human animals. "What do you mean?" Alice asked. You never "puzzle," you puzzle.

§45. So Tweedledee wants to repeat a poem about some Walrus and some Carpenter and some oysters ("oysters dear," the Walrus says, because he doesn't really care for them), and Alice develops certain opinions about what they did. That they did so "in the poem," as the saying goes, is no more relevant than that they could have done it in Knoxville. It may require some allowances but no essential change in how you deal with it. You wouldn't know how to describe in any other way the deliberate goings-on of chess pieces and cats. 'In the poem' locutions, assorted scare quoting, are like complaints, like insisting that the eye is not satisfied with seeing, which of course you may always do. Instruction in art is frequently the learning of ways to complain about what you see in art and so to complain about art.

§46. Those who so complain lack remembrance of former things. They are often incapable of repeating the poem that they will subsequently see in strict contiguity with what they do or think, only deliberately. They try to grow out of strict contiguity by suggesting that the poem belongs in a different world. And they may become proud of the operation, as one becomes proud of a new pair of glasses. To others, however, this might all look like unnecessary squinting. They would be puzzled by this hankering after the possibility of a new world, like someone who would want to change citizenship for no particular reason. What could be wrong with having firm opinions about what the Walrus did? Well, for one, walruses can't do things—they seem to lack something. But countries can't either, and you complain about Sweden all the time.

§47. Or, then again, you may be afflicted by loss of contiguity. Alice wants to repeat "How doth the little busy bee," "but her voice sounded hoarse and strange, and the words did not come the same as they used to." Later on she will admit to the Caterpillar that "I ca'n't remember things as I used." She tries to repeat a poem, only to realize that "some of the words have got altered." And when she attempts to repeat another poem, "her head was so full of the Lobster-Quadrille, that she hardly knew what she was saying: and the words came very queer indeed." " 'That's different from what *I* used to say when I was a child,' said the Gryphon. 'Well, *I* never heard it before,' said the Mock Turtle; 'but it sounds uncommon nonsense.' "

§48. There are two main attitudes toward such uncommon nonsense. The first attitude is that you blame the words or, rather, you attribute loss of contiguity to some action performed by words or performed upon words by some unknown agent: the words "have got altered." After all, you remembered the words, you wanted to repeat the words you remembered, and you put yourself in the position of going through the usual word-repeating motions and something else came out. This is like looking for your glasses, remembering you left them in the top drawer, opening the drawer, taking out a pair of scissors, and then claiming that the glasses "have got altered." It is no mere complaining. The White King complains about a pencil that "writes all manner of things I don't intend." Only he rightly concludes that he must get another pencil. When you blame words, however, you are not in a position to get anything else. Perhaps you could try a little harder instead, and you would find the missing words.

§49. The second attitude is to provide an explanation. Instead of unspecified deeds by unspecified agents, a concrete cause is mentioned. The words "came very queer," the explanation goes, because Alice's head is filled with another poem. And when that happens, you start talking nonsense. This is not just that the contents of Alice's head got in the way of her memory but, rather, that some specific contents did. What got in the way was the memory of another poem. Alice's loss of sense of a poem was caused by another poem. This would only happen to people familiar with more than one poem, and the probability of its happening might likely increase in proportion to the number of poems you are familiar with. The explanation accounts for the fact that people who are familiar with many poems frequently lose the sense that these may be helpful to them, and the sense that walruses are just like cats and poems are just like walruses. The impression of universal foreignness is caused by confusion; and the explanation of that impression often suggests a mystery about the substance of the confusion—some mystery about memory, about words, about language, and about you.

§50. The White Queen is "running across the country." Alice is intrigued by the sight: "How fast those Queens *can* run!" The White King remarks: "She runs so fearfully quick. You might as well try to catch a Bandersnatch!" What does 'Bandersnatch' mean? The word only occurs in a couple of poems. The King would be alluding to those poems, though of course not quite talking

about them. He borrowed a word from the poem perhaps in the hope that it would prove useful in describing a certain running Queen. If his head is filled with a poem, that doesn't seem to affect his memory in this particular case. "I'll make a memorandum about her, if you like." The fact that a word only to be seen in a poem can be used in a memorandum saves a world of trouble. It is not different from the fact that we can have opinions about the relative merits of the actions performed by the Walrus and the Carpenter, unmoved by their nonexistence.

§51. It is not that the King is seeing the world under the species of a poem, let alone under the species of art. There is no genus or species here. It is that the poem is as much a part of the world as is a moving queen. The relation between art and the world is not necessarily shown here as a relation of relevance. But just as the contiguity in the case of the Walrus is seen by the fact that Alice's opinions about his actions are similar to any other opinion about an action (they are not opinions-prime about-prime actions-prime), so it is here instanced by the fact that words-only-found-in-poems are similar to words found anywhere else, and people found in novels are similar to people found in Knoxville or in Thebes. The King's description is no less pure or less effective than if he were to have said that you might as well try to catch a sparrow. Of course, you may not get the description, but there are ways around that.

§52. Alice's head is now full of another "old song," a poem whose words "kept ringing through her head like the ticking of a clock, and she could hardly help saying them out loud: — 'Tweedledum and Tweedledee / Agreed to have a battle; / For Tweedledum said Tweedledee / Had spoiled his nice new rattle. // Just then flew down a monstrous crow, / As black as a tar-barrel; / Which frightened both the heroes so, / They quite forgot their quarrel.'" And then Tweedledum jumps and seizes Alice by the wrist: " 'Do you see *that?*' he said in a voice choking with passion . . . as he pointed with a trembling finger at a small white thing lying under the tree. 'It's only a rattle,' Alice said, after a careful examination of the little white thing."

§53. Alice says "It's only a rattle" as some people might say 'It's only a poem' or "You're nothing but a pack of cards!" What is the nature of Alice's disagreement with Tweedledum? Is the poem more like the description of a one-time occurrence or like a law of nature? There is a connection between

these questions. Alice, filled as her head may otherwise be with the poem, doesn't think the poem is like a law of nature. She remembers the poem about the rattle and the rest, she sees the rattle, but for her the concurrence of the Tweedles and the rattle offers no portent. She may remember the poem, but that's all there is to it. Unlike Alice, Tweedledum sees himself as being accurately described and, indeed, sees his actions as being accurately predicted by a poem. In fact, for Tweedledum the poem seems to be like a law of nature. He knows that if there is something like a Tweedledum, a Tweedledee, and a new rattle, there is bound to be a battle between the Tweedledum and the Tweedledee. Now he also knows there *is* something like a Tweedledum, a Tweedledee, and a rattle. And he would say he knows what he will do, inferentially as it were. He believes the poem like you would believe in a natural law. For him, the poem is not about some one-time past event, nonevent, or event-prime. It is about what happens. Most people would say that Alice's attitude captures the prevailing attitude relative to poems better than Tweedledum's. Seeing yourself as being accurately described by a poem sounds ludicrous and fanciful. How could the author of such an old song have known anything about you?

§54. And yet those who would shy away from seeing their own lives as illustrations of laws put forth by poems would be willing to accord Tweedledum dignity to the laws of nature. Tweedledum acts toward a poem as most would act toward some vaguely understood law of physics. Of course, we justify that dignity in altogether different ways, and that may be it. But the well-foundedness of our knowledge does not seem to be a primary concern here. Tweedledum's mistake, some would say, is to lend necessity to a poem and to draw inferences relative to himself from the poem. However, Tweedledum merely believes that he and Tweedledee are going to act in certain ways relative to a rattle. You don't disagree with him about physics or even about free will. Perhaps you are blaming him for the intensity rather than the belief.

§55. After Tweedledum and Tweedledee have had their battle ("And all about a rattle!"), the disagreement between them not showing signs of abating, Alice thinks, "I wish the monstrous crow would come." The crow eventually comes and she runs for cover. This was not a triumph of forecast. Granted, Alice now sees some of the occurrences around her as already described by the poem. But it could also be said that she now remembers the poem in a

different way—she remembers the poem as contiguous with her life. This is a triumph of poetry. The triumph of poetry, we could say, is the triumph of the fuzzy ideas caused by a poem. The triumph is shown here in what Alice does. She acts on those fuzzy ideas. The very Alice who had otherwise entertained doubts about the effects of poems, even poems that kept ringing through her head, now believes firmly that if you want to be a Queen you must get to the Eighth Square. Even before meeting Tweedledum, Alice sees her actions as determined by some idea she has about chess, just like Tweedledum sees his actions as determined by some idea he has about a poem. Alice's idea of chess is as vague and fuzzy as is Tweedledum's idea of poetry. Think of a number of activities loosely related to poems—saying things like "You might as well try to catch a Bandersnatch," having opinions about the Walrus ("I like the Walrus best"), which is, after all, a trademark of the unartistic humdrum, remembering poems and mixing them up with other poems or something else or anything, or hoping for some crow to come just because we remember some poem about a crow coming. It could be that the difference between Tweedledum, Alice, and you is just one of degree.

2

Furniture

(§§56–103)

§56. "I like the Walrus best." For you to say such things there is no need to imagine that the Walrus is an honorary person any more than to use the word 'fish' about him you are required to imagine him to have grown honorary gills. And you don't need any honorary psychology or honorary biology or honorary morality to deal with the Walrus. What you already more or less know from your various worldly interactions will amply suffice. Why would you need to *imagine* the Walrus to be a person in order for you to *say* that you rather like him? Are you suggesting that imagining the Walrus to be a person is like an admission ticket to saying true things about him? If so, it is not clear how ticket control would proceed unless, of course, everything were to be up to you. But if everything were to be up to you, you might as well just say it straight and save yourself the trouble of imagining anything.

§57. "Kitty dear, let's pretend." This is Alice's "favourite phrase." You may pretend that you are, or anyone is, something or someone else. "Let's pretend that you're the Red Queen, Kitty!" Alice seems to be wishing or hoping for something to be the case. And then there is this intimation that she might act accordingly. To that extent she is also wishing or hoping to get away with it,

since if something were the case she would have a reason for acting as she might. However, little seems to have come out of the ceremony: "Alice got the Red Queen off the table, and set it up before the kitten as a model for it to imitate: however, the thing didn't succeed, principally, Alice said, because the kitten wouldn't fold its arms properly." If only the kitten could have folded its arms, Alice might have gotten away with it. Or perhaps she might have pretended in a different way. Was this a technical failure?

§58. "Kitty dear, let's pretend." Could Alice be inviting a cat to pretend something together? Indeed, whatever is pretended seems to be pretended together here. It matters little that cats cannot be party to agreements and that Kitty does not exist. In that, at least, she is just like Alice. It also matters little that the object of this joint pretending entails the transformation of one of its parties. You can invite someone else to engage in a joint effort out of which you imagine a substantial change to the other person will result. What remains puzzling is the idea of a joint effort to pretend. 'Let's intend' sounds odd. You don't invite people to an intention party. No one else can intend for you either. 'Let's hope' or 'let's wish' sounds formulaic. Short of that, hoping or wishing together would be very similar to intending or pretending together. In all these cases you imagine people doing similar things, mentally. And this explains why the joint effort appears to presuppose some kind of agreement. You want to say that it is no coincidence that you are doing something, mentally, together. But doing *what*, exactly? The answer is believing that something is the case. "If you'll believe in me," the Unicorn says to Alice as one fabulous monster to another, "I'll believe in you. Is that a bargain?" An even odder thing is the deliberateness implied by this believing. You would think that you *believe* or *think* or *doubt* something is the case. Deliberately believing is either plain believing with an idle adverb or something similar to deciding. And you don't *decide* that something is the case. Such a decision would be moot, like deciding that it is raining. The difference between deciding what the case is and pretending that something is the case is that in the latter instance the members of the party must somehow know it isn't. The fact that it is raining seems irrelevant to deciding that it is raining—not so with pretending. When Alice invites Kitty to pretend that she is the Red Queen, both *must* know she isn't. So if there is an agreement it is that both parties know that a certain thing is not the case. This looks like lying. That's what they're doing together. They both know that what they are pretending is not the

case. Could they be lying then? Two people lying to each other in the same way are not lying. They need not be telling the truth, but they are not lying. Or perhaps pretending is just a very inept form of lying.

§59. Pretending often looks like a mental remedy for impossible surgery. You pretend as you would wish you could do something about some kitten, walrus, or person, namely, to turn it into something else. And still you know the kitten will never be able to fold its arms properly. But then perhaps you would be able to have it fold its arms *mentally?* And were you able to do so, would the kitten then acquire new feelings, thoughts, and opinions and queen feelings, thoughts, and opinions? Perhaps you would also have to pretend that as well, that is, you would have to hope or wish for everything to be queenly. And when you come across an honorary walrus, would you immediately have to pretend it to be a walrus? Or must you pretend in advance? When you see honorary stuff approaching, you begin pretending. But then if you see it as honorary, that wouldn't be necessary. And if you don't, how do you know that you would have to pretend? Well you don't, and this is exactly why you never really *have to* pretend, for example, that the Walrus is a walrus. What would be the point of such exertions?

§60. So *what* is the Walrus? The question sounds sensible and suggests a very widespread set of attitudes toward stuff found in art. These are attitudes toward furniture. The word 'furniture' means only stuff you find about the place. If the place is the real world, people sometimes say, such stuff will consist of things made, done, or found (including furniture in the stricter sense), people and other animals, and facts and all their various trappings. But the question also suggests that whatever you find in art is different from the usual furniture and is indeed furniture only in an honorary sense. In the arts, it is sometimes said, you only come across honorary creatures, honorary stuff, and honorary facts. The reason is that people sometimes say art furniture is brought along by your various talkings-about, and you do not bring real walruses into this world. True enough, but not very art-specific. The furniture of physics is brought along in similar ways, and you wouldn't describe your equations as real walruses. However, there are also similarities between the Walrus that we know to have eaten a great number of oysters in "The Walrus and the Carpenter," the Walrus Alice appears to like best than the Carpenter, at least at

first, and the nonhonorary walruses about the world. They both share tusks and whiskers and a certain gravitas.

§61. You may laboriously hope or wish to get away with the idea that the Walrus in the poem is a walrus. And yet no one that is not mad has ever entertained the least confusion about walruses-in-poems and walruses-out and fish-in-quintets and fish-out. So the point of such labors is again not clear. You don't have to imagine such imaginings. The question '*What* is the Walrus?' is the problem that it purports to solve. It insinuates that there are several kinds of furniture and then invites us to pretend there are. It may even go so far as to imply that there are various worlds. However, you may want to hold on to the robust sense that none of your actual dealings with the Walrus, nonexistent people and fish in quintets require that you entertain such possibilities.

§62. When you know how to deal with poems and quintets and sculptures, you already know how to deal with all sorts of other things. You have no particular problem with the Walrus, Walrus feelings, and Walrus facts. You know what to do and what to expect in most cases. You know, for instance, that Walrus garrulity is not to be explained by natural selection. And you know that some empirical moral psychology may come in attached, as when you say that the reason you think you like the Walrus best was because "he was a *little* sorry for the poor oysters." And you will sometimes be corrected by other people, though of course not by the Walrus, if you get it too wrong (but then again naturalists don't get corrected by walruses either). However, nobody will appeal to any elaborate considerations about kinds of furniture. They will not say that walruses-in-poems or fish-in-quintets cannot be the targets of human pity *because* they are honorary rather than walrusy or fishy. What something is is not anything like having tusks or gills. Also, no such furniture considerations are liable to change attitudes. "Consider anything," the White Queen says in despair, "only don't cry!" However, you will not stop crying when you consider that the Walrus that did some awful things was honorary, though you may or may not if someone tells you that he didn't mean to do any of those things, or that it won't happen to you or anyone you know, or that you got the story wrong and it all really was rather an amusing tale. You may occasionally be reminded that there are no unicorns, speaking walruses, or thinking Alices, but only if someone happens to believe that you don't know

anything about poems, just like in Knoxville you may be reminded that you can't expect to legally buy bourbon on Sundays, but only if someone believes you're from out of town. And when you ask tourist questions, the locals will not offer any considerations about furniture constraints but will most likely only invoke laws and customs. The things you learn about art are mostly of this prosaic sort, and so prosaic that the verb 'to learn' is probably an exaggeration. In this sense, the things you learn about art are totally contiguous with what you already know anyway. You learn, for instance, that walruses-in-poems may say things, but they won't hear you let alone understand you if you talk back, and also that they may say things in Swedish, though only if you know any Swedish. You also generally know that according to some people walruses-out may say things you won't understand very well, and at any rate they won't say them in Swedish. It seems that with walruses and Alices, in or out, you can never expect certain things to happen, though of course what you cannot expect may vary. But chances are, you already know that, and long before you come upon your first fish-quintet.

§63. 'Let's pretend' will most likely sound to you like the invitation to a pageant where after some joint exertion you hope that something in the world will be altered by the fact that you have mentally defined it in a certain way. Even if the very notion of mental definition looks suspicious, and it very much does, this is an odd belief that requires that you think that things always are what you think they are unless or until you think they are otherwise, in which case they will be otherwise.

§64. Still there could conceivably be cases when the locals would seem to offer more than merely customary constraints. Suppose you were to ask a Knoxville local where about town you could grow gills. In his response he would most likely not invoke a local ordinance, for example, one that would forbid the growth of gills on Sundays, or any local custom. However, the picture of a native *explaining* to you that humans cannot grow gills, telling you that certain creatures are insusceptible of changing their respiratory functions in such dramatic ways, in Knoxville or indeed anywhere, sounds ludicrous. You need no such explanations, and this is likely why those questions are so rarely asked. Of course, Knoxville locals know many Knoxville-unrelated things, though some of these Knoxville-unrelated things they believe, correctly or not, to be the basis of some of their local customs and ordinances. Ludicrous

questions always sound ludicrous relative to something, to some Knoxville-like place. The locals would most likely conclude not that you are a tourist but that you are a different life-form. And what they most likely know about Knoxville-unrelated things would almost certainly prevent them from entertaining that hypothesis seriously. And so the locals would probably think that you are mad, mad as a person who would decide to relocate permanently to the bottom of the ocean after having successfully pretended that he is a fish. The fact that someone asks you certain questions about books and quintets and the rest could make you suspect that he has missed a few basic things about art. And it's not the facts that he has missed: it's more like having missed the entrance to something; someone might know when Knoxville was established, and how many people live there, and still ask you where you could grow gills about the place. It is possible to know the facts and miss the entrance. But, then, when you miss the entrance, talking about the facts will sound like mere noise. You might even want to say that it would not be talking about anything.

§65. You may change your mind about the Walrus, about books, and about the quintet. Almost anything can cause such changes. When that happens, you don't change your mind because you have become persuaded that they are or have become something else, let alone that they have become honorary or dishonorary in any way. Changing your mind about a piece of art is not unlike changing your mind about a person. It has nothing to do with changing ideas about *what* anything is. Very rarely will you come to see a quintet as a tree, and when you describe a crow as a monster, you mostly mean a monstrous crow. You don't *find out* that people are trees. You may come to talk about the quintet in very different ways, cease to care, and forget all about it, but such demotions do not require that you downgrade its furniture status, from turtle to mock turtle as it were. You will still say that a mock poem is a poem, a sham quintet is a quintet, a false painting is a painting, and a bad person is a person. On the other hand, if you know it's false butter, you won't call it butter, unless you're lying, that is. Not calling a bad person bad is not lying. Of a bad person you won't say you can't believe it's no person.

§66. The Mock Turtle is an animal, and one that does not exist. And a character is frequently, though not always, a person, and often a person that does not exist. "You look a little shy," the Red Queen says to Alice, "let me introduce

you to that leg of mutton." Surely Mutton seems to be nothing but a character. Would this mean that the Queen is introducing Alice to a character? Of course not. Introducing something as a character would be as strange as introducing someone as an attribute: 'Meet blue,' 'Meet false,' 'Meet even.' We wouldn't be able to begin to make sense of such ceremonies. So 'leg of mutton' is probably not best described as the name of a character, like 'shade of blue' or 'kind of false.' It helps little to say that action-capable pieces of furniture in books are characters, let alone nothing but characters. It suggests an unnecessary kind of furniture. If you need to have a technical term, 'agents' would do well enough. Alice calls them "creatures," an even better word. Would you seriously expect all action-capable furniture to talk back? And would describing these pieces of furniture as characters change your expectations, as when you describe something as false butter? You may often be disappointed by being told that some of those creatures did certain things or had certain thoughts, usually things and thoughts of which you hadn't previously been aware. But this is just what being disappointed means. Alice is disappointed when she is reminded that the Walrus ate more oysters than the Carpenter. But in many, though not in all, books you wouldn't be disappointed by being told that the people there do not exist. You already know that, because you have learned it, as you have already acquired some rough distinctions between books, between things you are supposed to do relative to certain books, between ways of talking, and much more.

§67. It seems accurate to say, as most people in fact do, that in the Alice books those action-capable bits of furniture comprise people, animals, dishes, or even chess pieces. And in Knoxville it may be helpful to know that you can't get bourbon on Sundays. Those various creatures say things and do things and have thoughts, opinions, and attitudes, and they move about. They look very similar to the rest of us, only quieter. That is probably why our standard bits of moral psychology also work for them. You don't wince when you accuse Mutton of being intemperate. And, indeed, the words we use to talk about them are, with few allowances and even fewer exceptions, the words we use to talk about ourselves. And the questions you ask about them are similar to the questions you ask about your sister. 'But surely none of them exists.' You know that and, what is more, make no mistakes on that front. It just so happens that you have no separate set of words for nonexistent furniture. You don't talk about nonexistent people in scare quotes. You don't feel-scare-quote the feelings and beliefs you develop in relation to nonexistent people. And this

indicates that there rarely is the risk of any confusion, even when you say that the greatest tragedy in your life was the death of Mutton. You don't "like" the Walrus best. You don't have to pretend to like it best. You like it best. If people know you well enough they will know the signs of your having changed your mind about things; and they will also know when you change your mind about the Walrus.

§68. Why can't the kitten fold its arms? Surely there must be something substantial about it that prevents it from being turned into a red queen. And if there isn't, then there should be no reason pretending wouldn't work at all times. Perhaps there would be some honorary physiology or an honorary anatomy that could explain why an honorary kitten shouldn't fold its arms in certain ways. For that, however, their normal cousins would do. Ordinary anatomy explains why an honorary kitten can't fold its arms. What you perhaps mean is that you wish for an explanation that would account for the possibility of bringing about a talking red queen by folding a kitten's arms. Since there is no such explanation, you would then say that the reason you can't bring about red queens out of kittens whose arms are folded in certain ways is because there is something in kittens that resists their being turned into red queens. However, since these aren't real kittens, it is hard to see what that would be. You may talk like an engineer as much as you want, but there is no materials science about anything you say.

§69. Alice took the Red Queen off the table "and shook her backwards and forwards with all her might. The Red Queen made no resistance whatever: only her face grew very small, and her eyes got large and green: and still, as Alice went on shaking her, she kept on growing shorter—and fatter—and softer—and rounder—and—it really *was* a kitten after all." When you shake nonexistent red queens, there is "no resistance whatever." This must be because they are nonexistent—no existence, no resistance. Not existing could make you more inclined to metamorphosis, to growing shorter, fatter, softer, and rounder, and to becoming something else. Could existence be similar to protection from certain inordinate changes, similar to an immune system? In any case, even if the Red Queen "really *was* a kitten after all," she was not a real kitten. And so there would be no reason, upon further shaking, she would offer any resistance. Informing the kitten of the fact, telling it it is nothing but a nonexistent purring piece of furniture, doesn't seem to advance matters

much either. It adds nothing to what we already know, and it adds nothing to what the kitten may know, since of course, being nonexistent, it may not know anything.

§70. Alice addresses both Kitty and the Red Queen as "Your Red Majesty." This is no honorary title. The title does not scare-quote anything, nor would anyone in Knoxville need such scaring. That neither exists, or that no pretending transformation has occurred, is immaterial to the use of the title. Rather, "Your Red Majesty" means to capture an important affinity between the Red Queen and the kitten. It offers a description of the fact that the kitten once was a Red Queen. Forget Alice's gentle sarcasm. The title is her way of saying that something is like something else. The kitten is the nonexistent animal formerly known as Red Queen. The title talks about Kitty. Calling furniture 'Your Majesty' is a description of that furniture, perhaps shorthand for historical description, or a promise of adventures to come.

§71. Alice can't pretend the kitten into a Red Queen. It may look like the problem is with the arms, but since this is a nonexistent kitten, the problem may have to do with the pretending. And so their affinity, expressed by Alice's addressing them both as "Your Red Majesty," must be independent from pretending. Perhaps we could start instead by having it *admit* to its having previously been something else. Alice "put the kitten and the Queen to look at each other. 'Now, Kitty!' she cried, clapping her hands triumphantly. 'Confess that was what you turned into!'" This is another version of the trouble with the arms. You can't bring Kitty face-to-face with the Red Queen any more than you can bring the proverbial duck face-to-face with the rabbit. You may believe that this is because Kitty keeps turning its head, and so that it is to be accounted for by some more feline physiology and anatomy, however propped up by honorary juices, but the trouble appears instead to have to do with making cats admit to propositions. And this is of course because their admissions entail talking back, and there is always this "very inconvenient habit of kittens . . . that, whatever you say to them, they *always* purr." So you can't turn a cat into a queen by having it admit to the fact either.

§72. There is little mystery as to why Kitty won't admit to propositions, and Alice is only passingly surprised that it doesn't. In fact she has other ways of making it talk. Of course, 'making it talk' is rough and imprecise, since cats,

and especially nonexistent ones, can't ever talk. It would be more accurate to say that Alice talks about Kitty. ". . . It turned away its head, and pretended not to see it: but it looked a *little* ashamed of itself, so I think it *must* have been the Red Queen." Alice's talk looks like reasoning. She appears to have reached a conclusion, even if she isn't too sure about it. The conclusion depends on evidence. The evidence is coextensive with how Alice talks about Kitty, how she describes it, how she says it pretended not to see the Queen, and how it looked a little ashamed. What she says about Kitty requires that Kitty have certain abilities (and there is nothing mysterious about 'requires': what she says about Kitty also requires that it have a turnable head). According to Alice, Kitty can intentionally simulate behavior. This is what Alice means when she says that the kitten pretended not to see the chess piece. Simulating behavior implies being able to entertain ideas about behavior, as well as about other people's expectations. Such ideas are of course implied by describing Kitty as having pretended not to have seen the Queen. And, Alice suggests, Kitty can also feel ashamed. This seems to indicate that it is her opinion that Kitty is also capable of entertaining ideas about its own behavior and indeed of entertaining unfavorable descriptions of behavioral descriptions. These are all fairly sophisticated abilities, abilities that require not only attitudes or reactions but attitudes about attitudes and attitudes about reactions. Both pretending not to see something and feeling ashamed of something require at the very least having attitudes about attitudes, your own and other people's, and having opinions about something as being the case. So in both instances Kitty must be able to refer to assertions that state that something is the case, as when you do when you claim that it is not the case that what you did yesterday is anything to write home about. This you do by talking. Talking about Kitty often suggests that Kitty can talk. Kitty may only purr, and may not exist, but it otherwise talks up a storm.

§73. This of course is how you talk about people and how they talk, in Knoxville and in books, how you talk about creatures that can talk back, people who don't exist, and dead people. You may or may not expect cues, but you tend to allege clues. However, the diffident tone of Alice's conclusion ("I think it *must* have been the Red Queen") is not specific to the fact that the kitten does not exist, and so to the fact that she does not expect any cues from it. It does not denote a doubt that we may have only when what we are talking about does not exist. It indicates instead a common enough difficulty we may

experience about the truth of our various talkings-about, and a difficulty as to which the actual existence of cues may often be of little help. The doubts and problems of a nonexistent person, as indeed the goings-about of chess pieces and legs of mutton, may therefore be very similar to our own. A talking chess piece may make more sense than your existing neighbor. "You're thinking about something, my dear," the Duchess conjectures. And Alice feels certain that the Mouse "must really be offended." And there are questions the Dodo cannot answer "without a great deal of thought." And the Pudding remonstrates ("I wonder how you'd like it, if I were to cut a slice of *you,* you creature"). 'Pudding,' 'Dodo,' 'Duchess,' and 'Alice' may as well be specifications of a variable. There is indeed something economical and compressed about all talking about, something shown by the fact that an enormous amount of different conjectures, feelings, and descriptions can be dealt with in generic talking ways. But this suggests that in important respects you only have so many ways, and all generic, of talking about action-capable furniture. And this may occur apropos of real people, books of all kinds, but also, unexpectedly, quintets ('a series of modulations eventually leads back to the movement's main key'). Even landscapes and buildings have occasionally counted as action-capable furniture. Those generic ways entail assumptions about intentions, attitudes, wishes, and so forth. This happens to such an extent that you may justifiably conclude that talking about art *is* talking about action-capable furniture. The furniture and its attending train of capabilities, you could say, come with the generic talk.

§74. "'O Tiger-lily!' said Alice, addressing herself to one that was waving gracefully about in the wind, 'I *wish* you could talk!'" You need not entertain any florid beliefs about talk. Most furniture can't talk, though saying it may not explain anything you didn't already know. "'We *can* talk,' said the Tiger-lily, 'when there's anybody worth talking to.'" "So astonished that she couldn't speak for a minute," Alice asks it if all flowers can talk. "'As well as *you* can,' said the Tiger-lily. 'And a great deal louder.'" According to the Tiger-lily's subtle emphasis, flower-talk is directly proportional to your own talk. If you can talk, flowers will, and they will do so displaying the sort of elaborate feats of indirect speech and assumptions about intentions and attitudes that you matter-of-factly do. This is why flowers will talk Swedish if you do, though only if. However, the Tiger-lily also says that flowers can talk louder than you. If flower-talk is directly proportional to your own, how can they do so?

If anything, flowers would seem destined to do it in a quieter way, as would befit nonexisting creatures. You appear to be the master at all times, and, as Humpty Dumpty says about words, you certainly "can manage the whole lot of them." How, then, is one to reconcile this reasonable assumption about the direction of causation with Alice's not always cheerful sense that the various creatures constantly "order one about, and make one repeat lessons" and reconcile what we know about management of the whole lot with the familiar loudness of flowers, nonexistent people, chord progressions, and, indeed, with the very loudness of art, and its very prominence?

§75. On the one hand, you know you wouldn't have any art without a series of attitudes and abilities, certainly not without being able to talk about furniture and not just art-common furniture. On the other hand, how you deal with art and the roles art plays in your various goings-about, art-related and not, seems to include possibilities that prima facie appear to escape the dumpty notion of a strict unilateral control. That how you talk, and that you talk, appears to be the cause that many creatures talk back, but this does not seem to entail ventriloquism. And it is not that in any way you always mean them to say what they do, let alone as loudly as they sometimes do it. You would often do without the constant lessons afforded by quintets and poems. Indeed, the very suspicion of ventriloquism would be at odds with some of the roles and functions the various arts may have for you. 'Mutton talking is only you talking in a certain way' is the sort of nothing-but explanation of art that will unfailingly miss the sources of your interest. The possibility of surprise, for one, seems to be an important part of the interest. There is something deeply wrong about defining art as the mere business of organizing surprise parties for yourself. The sense of such wrongness is what often leads people to describe art emanations as a series of quasinatural events independent from you and caused elsewhere. And so you would be surprised by a quintet like you might be surprised by a rain shower. And *this* is also what often leads those other people who correctly smell the fishiness of the event doctrine as imagining mental ceremonies that could, by mutual arrangement as it were, account for the possibility of your being surprised by something that you have caused. You want to say both that art is never an arrangement and certainly no arrangement with yourself, and also to acknowledge that it depends crucially on how you talk and on that you talk. You want to say that art is neither like a natural event nor like the product of an agreement.

§76. 'I can hear it' appears to exclude 'You're nothing but a pack of cards.' If
you say that something is nothing but a pack of cards, you are indicating that
you won't hear it at all. And if the phrase 'You're nothing but a pack of cards'
means that you don't care, 'I can hear it' may mean that you care, sometimes
even more than you care about yourself. However, by being taught art-related
things, and furniture-related things, you are really never taught to listen to
any voices. You are taught instead that certain things matter and, perhaps
indirectly, are also taught certain things about things mattering. You may for
instance learn that the answer to 'Why care?' can only be given after you care,
retrospectively as it were. The question does not require that you deliberate
about it until you have any sense of what it means. And so only after having
acquired a sense that things may matter will you be able to talk about what
matters. You have no use for the business of describing things regardless of
any idea as to what you would do to them, and with them. You never come
across things, just as you never *find* morals or meanings.

§77. You may care, and even learn to care, about other people in this way,
and you will likely care only about certain things. The sheer volume, the sheer
loudness of what you care about, may become unpleasant, and you may even
complain that certain cared-about creatures always tend to "order one about
and make one repeat lessons" and wish for a return to the time when those
things didn't matter to you. And that you care of course may be shown in
many ways. You pay attention to certain things, you surround yourself with
certain things, you act so as to prevent them from disappearing, you remem-
ber certain things, you give presents, you talk about things, you bore or charm
people with your talk, and you honor and give all sorts of precedence to cer-
tain things. And in none of these cases would you entertain, if you care, that
is, the possibility that that is all part of the surprise parties you regularly throw
in honor of yourself. In fact, you are sure that if something is talked about as
something that matters, then the point of such talkings-about is not yourself
either. It matters to you, but it is not you who matters the most.

§78. "O Tiger-lily!" "O Mouse!" Is this how you speak to furniture from
which you expect no cues? Is there any "right way of speaking to a mouse"?
Alice seems to believe that a certain solemnity is required. She tries the voca-
tive, perhaps because "she had never done such a thing before, but she remem-
bered having seen, in her brother's Latin Grammar." In the case of the mouse,

it doesn't seem to work. Her first explanation for the fact is that the mouse doesn't understand any English. "I daresay it's a French mouse, come over with William the Conqueror." Alice tries French next. "Où est ma chatte?," a sentence from her French lesson book, causes the mouse to give "a sudden leap out of the water," quivering "all over with fright." "'Oh, I beg your pardon!' cried Alice hastily, afraid that she had hurt the poor animal's feelings. 'I quite forgot you didn't like cats.'" This seems to do the trick. "'Not like cats!' cried the Mouse in a shrill passionate voice. 'Would *you* like cats, if you were me?'" So the Mouse knows both English and French.

§79. The Mouse of course knows whatever Alice knows and will react to whatever language *it* knows. That it didn't react to the English at first may only show that it didn't intend to. And its not intending to speak comes from the talking that is done about it. Having "looked at her rather inquisitively", and having "seemed to her to wink one of its little eyes," the mouse, soon to become Mouse, appears capable of looking back in deliberate ways, and probably also of asking questions, winking, and, more to the point, appears capable of wanting to do such things; and thus it appears perfectly capable of not wishing to speak. And its behavior also shows that it is capable of relating "Où est ma chatte?" with 'Where is my cat?' and 'Where is my cat?' with 'Lo, a cat.' It probably has feelings, and feelings that can be hurt. The Mouse is a very complete mouse, just as Alice is a very complete person. Nonexistence does not seem to detract from completeness.

§80. And still Alice will sometimes offend the Mouse, as she will often offend and be offended by the furniture about. She will suggest that various threats to the Mouse's integrity are looming, mostly cats and dogs, and will describe cats and dogs in ways that the Mouse will consider offensive. Dinah, a cat, "is such a nice soft thing to nurse—and she's such a capital one for catching mice—oh I beg your pardon!" And a farmer nearby owns a nice little dog, "and he says it's so useful, it's worth a hundred pounds! He says it kills all the rats and—oh dear!" And that a mouse may react in an offended way is to be explained exactly how you explained that you can be surprised by something you did. You can make mistakes. The Mock Turtle asks Alice whether she has ever been introduced to a lobster and "Alice began to say 'I once tasted–' but checked herself hastily, and said 'No never.'" The hasty interruption suggests that Alice can learn, and so is capable of developing the impression of

having done something wrong. And this is not the sense of wrongness that comes from having done anything extraordinary, something that no one else usually does. You mostly offend people in the usual ways.

§81. Alice only likes insects "when they can talk." Where she comes from, she explains, "I don't *rejoice* in insects at all . . . because I'm rather afraid of them— . . . But I can tell you the names of some of them." Then, the Gnat asks, "What's the use of their having names . . . if they wo'n't answer to them?" This seems to describe two different paths. The first is that you may have a name for something, but then you don't rejoice in it; the second is that you may rejoice in it, but then it must be able to talk. That they are able to talk is related to how you do the talking, in the sense that your talking always suggests what they can do back. But surely both being able to talk to them and being able to tell their names are ways of talking about them. Perhaps the difference is that the first way does not induce rejoicing.

§82. You may know your "list of insects" and may even be able to expand it by including new items, and describing those new items in ever-more complex and prolix ways. The Rocking-horse fly is "made entirely of wood, and gets about by swinging itself from branch to branch," and it lives on "sap and saw-dust." And Elsie, Lacie, and Tillie "lived at the bottom of a well" and lived on treacle. This is what Alice calls the "grand survey," "something very like learn-ing geography." Why should you need a grand survey? That you know the name of something you talk about cannot capture the fact that you deal with it in certain ways, and are surprised by it, and that it may be offended by you. The grand survey does not seem to teach you anything about each of the vari-ous pieces of art or, rather, does not explain that you rejoice in them, or that people offend them or are offended by them. And since they won't come when you call them, having names for them also seems superfluous. What you ap-pear to be saying is that third-person descriptions, of the sort offered by grand surveys, don't usually seem to be able to pick out the source of your interest, or at least the sort of interest that explains that art may be so important to so many people. Knowing your "list of insects" is not like caring for Mutton.

§83. Take the second way: "After they had been talking together so long," Alice "couldn't feel nervous," even when facing an insect "about the size of a chicken." Talking together would seem to be a measurement of familiarity

and also to breed, or at least to convey, rejoicing. This also seems to express something important about books and quintets and films, even about those the size of a chicken. That you only grand survey them, that you only call them names, is often a sign of nervousness, a sign of your own lack of familiarity, or possibly even a sign that you don't care. Perhaps your familiarity with what you call art cannot be instanced by calling it names. Is the difference like that between having flown over Knoxville and having been to Knoxville? While flying over Knoxville, you won't say '*here*, in Knoxville.' Surely people who are familiar with such things, you would say, would talk about them in a different way, would use 'here' in a different way, perhaps with a special emphasis. Would the emphasis come from having been somewhere, like suntan?

§84. And yet people who have never been to Knoxville may talk about it in very familiar terms. And the greatest tragedy in your life was the death of Mutton, though of course there was no 'here' for Mutton to be anywhere together with you. And Mutton's nonexistent cohort wouldn't necessarily express a higher degree of understanding of the import of Mutton's death. Alice, for one, would not mind much. And you may have been to Knoxville born, and use 'here' in all the regular emphatic ways, and still have no sense of Knoxville. Proximity, we would say, is not inherited, as there is no native position from which you can determine it. Natives may speak in certain ways, but not because being a native has determined how they speak. And so the acquaintance of a native may often be futile. The Knoxville natives are not any *closer* to their own liquor laws than you are, though of course the laws may be more familiar to them than they are to you.

§85. And so the fact that you indulge in list-making does not necessarily show incomprehension any more than the fact that you address mice and flowers in the vocative case will grant you any special familiarity. There is no one correct way to address mice and flowers and quintets, and there is nothing inherently wrong about third-person descriptions. The grand survey may express a degree of honor that no grand tour would ever equal. And those who claim to be familiar with many things, from fish-quintets to mice-books, are actually claiming that having used 'here' in many different circumstances would grant them a special position. But you can go about the world, sauntering from Quintet to Knoxville, and claim your various 'here' as added items to a collection; and the very recurrence of your claims to familiarity may well

be just what you otherwise deplore in grand surveys. You may remain a tourist all your life by claiming familiarity with all sorts of places. In fact, that you talk in certain ways is neither necessary nor sufficient indication of the role the various bits of art have for you. The kind of familiarity that you want to apprehend may be indicated by many other things instead. And this is of course a difficulty common enough in our knowledge of people. That you have met someone does not mean that you may claim to know the person. She may even have spoken, but that does not necessarily help. There is no right way for a person to speak so as to allow you to justifiably say that you have been "there." If there was, meeting someone would amount to knowing the person. However, there is no knowledge by meeting.

§86. You often become acquainted with bits of art by introduction, as you sometimes say you are introduced to people and other furniture. And bits of art are introduced to you in similar ways. And they may often not look familiar. When the Unicorn first saw Alice, "he turned round instantly, and stood for some time looking at her with an air of deepest disgust. 'What—is—this?'" he said "at last." His question is in part similar to 'What is the Walrus?' and the 'what,' as the very fact of the question, may indicate that in both cases something must have gone awry with the introduction. But there is something else about the Unicorn question that sets it apart from 'What is the Walrus?' and this is of course the second pronoun, "this." When you ask 'What is the Walrus?' you already know a name from a list, some insect list, and express puzzlement as to the nature of the furniture item that is described by the noun 'Walrus.' When you ask 'What is this?' the implication is that there is no list. If 'this' is a pronoun, there doesn't seem to be any noun around for it to be a pronoun of. 'This' means that there is something about where you are whose nature you don't know. In this, 'this' is like 'I' in 'Who am I?' The first time you were introduced to the fish-quintet you may have asked 'What is this?' And you also may have asked yourself 'Who am I?' But in either case what you really wanted to know is where you were. You always are there where 'what' and 'who' questions occur. Art has the reputation of eliciting such kinds of questions, and this is thought to be an important feature and its important merit. And it matters that those are questions concerning something about you that is not on any insect list.

§87. But of course it also matters that you are introduced to bits of art as opposed to merely finding them, like the Duchess finds morals and Humpty

Dumpty finds meanings. You don't ask 'What is this?' when you *find* a meaning. And just like it doesn't come with an instruction manual, so art cannot introduce itself. It matters then that someone, often someone else, perhaps someone you trust, is doing the introduction. You may imagine introduction as a ceremony. Haigha introduces Alice to the Unicorn: "This is a child! . . . We only found it to-day. It's as large as life, and twice as natural!" He also believes that there is a proper way to introduce furniture to furniture. You spread your hands toward what is being introduced in what is called "an Anglo-Saxon attitude." But this is just the continuation of vocative by other means. Just as no form of address is required by the nature of art, so there is no one proper way of being introduced to it.

§88. However, not all introductions are of equal value, of equal consequence. Certain people are better at talking about art than others, and some are better at introducing you to it. And it is perfectly possible to say that one was badly introduced to a piece of furniture. Since most furniture, and certainly quintets and books, won't answer back or complain, won't, until you develop a certain care for them at least, act offended in the way the Mouse did, perhaps a bad introduction has to be thought of as something like a bad introduction *of you*. Alice is often badly introduced and is never given the chance to complain. Pat introduces her to the White Rabbit as "an arm"; the White Queen introduces her to the White King as a volcano; the Pigeon believes it has met a serpent; the Rose declares that "There's one other flower in the garden that can move about like you." And the Lion, upon having been introduced to her by the Unicorn (to whom in turn she had been introduced by Haigha), asks, "Are you animal—or vegetable—or mineral?" You know that none of these descriptions is a good description of Alice. And this may have to do with the fact that in possibly various ways they are all nothing-but descriptions. They all suggest that Alice is nothing but a 'what,' at least for introductory purposes. Of course, you might hope that these various creatures only lack the relevant vocabulary, and that given enough time they might improve on their initial descriptions. However, none of these creatures ever appear inclined to change their introductory impressions of Alice. *Alice* never manages to demonstrate that their introductions were wrong and that she has been badly introduced. This means both that Alice cannot argue with those who describe her and that the impressions of those first meetings cannot be corrected, as you would correct a mistaken calculation. In this she is just like the hapless fish-quintet.

§89. 'What is this?' is supposed to be answered by introduction, though introductions may go wrong and you should not expect any immediate signs of wrongness, like, say, a rash developing. 'Who am I?'—that other question about unfamiliar things-about—is not. You generally believe that no one else has the right to introduce you to yourself, of pointing you to yourself, and that no Haigha will tell *you* who you are. Art won't tell you who you are either, if by that you mean that it will talk back. And so you imagine another ceremony of introduction, what the White Queen calls "a-dressing myself." When you a-dress yourself, however, "every single thing's crooked." You sometimes know when you have got the a-dressing wrong, and still there is no rash, but you only have yourself to blame. And the connection between the two questions and the two kinds of ceremony is that there really never are any answers coming from who or what you a-dress. "'Am I addressing the White Queen?' 'Well, yes, if you call that a-dressing.'" *If* you call that a-dressing, then all talking about is addressing, and the only way you go about either question. And in either ceremony talking about is talking about what is about you the most.

§90. "'You look a little shy: let me introduce you to that leg of mutton,' said the Red Queen. 'Alice—Mutton: Mutton—Alice.'" This suggests introduction and something about introduction. It suggests that in the ceremony of introduction, Alice stands to Mutton as Mutton stands to Alice, though of course that Alice is introduced *to* Mutton also suggests that there is a hierarchical difference between the two bits of furniture and that Mutton is somewhat more important in the overall scale of furniture. "The leg of mutton got up in the dish and made a little bow to Alice; and Alice returned the bow, not knowing whether to be frightened or amused." Both reciprocity and hierarchy appear to be internal to introduction. Alice finds it all a little frightening and comical. You would also find it a little comical that the fish-quintet would return your bows, and frightening that people could think that they are introducing *you* to it. 'You look a little shy,' people sometimes say, 'Let me introduce you to Knoxville.' Another equally frightening thought is that some people might think that introduction to art would constitute a remedy for your shyness, a remedy for your lack of social graces.

§91. Introduction goes awry when Alice offers to give the Red Queen a slice of recently introduced Mutton. As the Queen explains, "It isn't etiquette to

cut any one you've been introduced to." Alice will quickly infer that she'd better not be introduced to Pudding, "or we shall get no dinner at all." The Queen still tries to avert the impending breach of etiquette by introducing Alice to Pudding in articulo mortis—to no avail. Alice has now "conquered her shyness" and cuts a slice. The amputated Pudding calls it "impertinence." The whole scene suggests that becoming acquainted with something excludes eating it. If introduction is a possible form of care inducement, then you either care in the way prescribed by the introduction or you cut. But of course if you care in that way, you don't eat. You simply don't *eat* those that have been introduced to you. That you are introduced to art suggests that there are certain things you should refrain from doing afterward, namely, eating it. It is a breach of etiquette not to reciprocate in kind. However, it is also not simple to determine what reciprocating in kind to Quintet or Knoxville might be.

§92. And so you often are told that the etiquette is to leave it be. You are introduced to art and then you leave it be. Anything else would have been impertinent. You leave the furniture as you found it, like you clean after an honorary meal. Indeed, you are only allowed to take Knoxville and Quintet in your heart or some such honorary place. No eating is allowed *of* the premises. But, on the other hand, if you are also cured of your shyness by having been introduced to these pieces of furniture, anything could happen. You expect art to change you and do not expect art to be changed by you, that is, you do not expect your actions to have any consequences. This may seem unfair, but it is mostly odd. If it is supposed to promise reciprocation, introduction fails in an odd way. Reciprocation is an odd way of talking about art in the sense that it wrongly assumes that nothing ever happens.

§93. And what would such a prescribed way, such etiquette, look like? Perhaps it would be similar to a local ordinance, something pertaining to art, as something might pertain to Knoxville. In a courthouse, the Dormouse reminds Alice that she has "no right to grow *here*." And, having been asked a question, the Fawn explains to Alice, "I'll tell you if you come a little further on . . . I ca'n't remember *here*." The adverb that both explanations share is what gives them their odd aspect. You would not define growing as a *local* right, or memory as a *local* ability. And it is hard to imagine an ordinance that would state that in Knoxville you are not allowed to sweat, or engage in multiplication. Art may be like being in Knoxville, but art etiquette often tells you that you

shouldn't do things that your notion of the thing suggests would be insusceptible of ever being done, in Knoxville or anywhere. For instance, you are often told that you are not supposed to *remember* certain things. You're not supposed to remember that most of the furniture does not exist, that it does not talk back, and you're not supposed to remember what the Walrus is. And you are supposed to achieve this state of decorum by pretending, as if when entering Knoxville there would be a sign that read 'Pretend.'

§94. The Fawn remembers: "'I'm a Fawn!' it cried out in a voice of delight. 'And, dear me! You're a human child!' A sudden look of alarm came into its beautiful brown eyes, and in another moment it had darted away at full speed." Its remembering puts an abrupt end to a joint walk in the woods. Once the Fawn remembers, it remembers itself as possible game for Alice. And so there seems to be no relationship with certain bits of furniture unless you forget certain things. But the difficulty is that you cannot *decide* to forget. And so the oddness of the ways in which Fawns and books are introduced to you, the oddness of the ways in which art is usually introduced to you, comes from the fact that the various Haighas treat forgetting like raising your hand or buying bourbon on Sundays. This is what Anglo-Saxon attitudes amount to. They promise deliberateness all the way down.

§95. Questions like 'What is the Walrus?' and 'Who am I?' may have many different consequences, and so it matters to know when exactly such questions are asked. They may induce talk of unnecessary furniture; also, they may put an end to various amnesic interludes and spoil the effects of the induced talk. Introduction is often a complex mixture of talking about and pointing out that intimates knowledge as a function of having met, of having made the acquaintance, of some hitherto unheard-of entity. But those questions also may interrupt particular fantasies. In this latter capacity they are like 'What's for dinner?' in the middle of a conversation, as often perceived as a threat as an unnecessarily fierce expression of care.

§96. If something is nothing but a pack of cards, you may ask what's for dinner. That something is nothing but a pack of cards in fact may mean that you won't be able to eat it. This is the complaint of someone who has discovered that there are no honorary persons or honorary sounds or honorary images that honorary-perform honorary actions often by honorary talking, and also

the complaint of someone whose fawning about the woods was brought to an end. It is the dark side of pretending: the whole situation will show itself as a classic case of sour game. And *you* will show yourself in an unflattering light for only having realized that so late in life, perhaps as late as poem school, that most furniture is nothing but something else.

§97. The Walrus and the Carpenter persuade a few young Oysters to go for a walk on the beach. After a mile or so, they stop. The Walrus announces talk as you would announce a call for papers: " 'The time has come,' the Walrus said, / 'To talk of many things: / Of shoes—and ships—and sealing wax— / Of cabbages—and kings— / And why the sea is boiling hot— / And whether pigs have wings.' " The Oysters ask him to wait a bit "before we have our chat." They need to catch their breath. Upon which, the Walrus says: "Now, if you're ready, Oysters dear, / We can begin to feed." They are all eaten. There never is any chat.

§98. Young Oysters may be the most stupid and senseless of animals, but one may also wonder about the ceremony. Both Walrus and Carpenter observe the vocative proprieties. The Walrus calls them "Oysters dear." The Carpenter addresses them as you would address a flower or a foreign mouse: "O Oysters!" The Walrus thanks them for their visit: "It was so kind of you to come! / And you are very nice!" And the Oysters expect reciprocation. "After such kindness," eating them "would be / A dismal thing to do!," almost like an academic hypothesis. However, the only form of reciprocation available is the one suggested by the verb "to feed." The bread-and-butter talents of the Carpenter pale in comparison to the way in which the Walrus uses words like "we" and "nice." We can begin to feed, but some of us will do so in the capacity of fodder. And you are very nice, though in a rather dish-sense of the term. It matters that most of the speaking is done by the Walrus.

§99. By way of postprandial dirge, the Walrus again remarks, "It seems a shame . . . /To play them such a trick." He adds, "I weep for you . . . I deeply sympathize." No wonder Alice likes the Walrus best. That he was a little sorry for the Oysters she believes can be inferred from how he talks. It is, however, not yet clear what the role of talk is in the whole ceremony, what its role is in the knowledge of oysterous furniture. It seems part of the whole getting-acquainted business, but it yields no acquaintance. Could talk be "a trick"?

§100. If you factor in walrusy ulterior motives, talk is *part* of a trick. But there is nothing inherently tricky about talk in the whole ceremony. The Carpenter complains that "the butter's spread too thick"; the Walrus declares that "a loaf of bread . . . / Is what we chiefly need"; the Oysters say that "some of us are out of breath." They all appear to mean exactly what they say. Perhaps, then, only a certain kind of talk, Walrus-talk, dirges, and calls for papers, is tricky. If so, it would cause effects, namely, those of tricking Oysters into—what exactly? Nor is talk propitiatory in a scheherazadian way. No Oyster succumbs to talk, or changes his mind because of talk. There seems to be no direct link between talk and certain effects. And no one talks back. When the Oysters express some apprehension and turn "a little blue," the Walrus talks about the weather and the view. And no promised panel on the warming of the oceans or the possibility of porcine wingedness ever comes about. Equally important, when the invitation is first issued by the Walrus, an older Oyster, perhaps more experienced, "looked at him, / But never a word he said: / The eldest Oyster winked his eye, / And shook his heavy head—/ Meaning to say he did not choose / To leave the oyster-bed." So silence can mean all sorts of things.

§101. The Walrus-talk is neither trick nor nonsense. His call for papers comes across as a list of topics held together by the thinnest of alliterations. It would so appear that part of the ceremony is then that you make verbal noises for no particular purpose. Nonsense, some people call this. This assumes that you could deliberately *make* nonsense, as you could produce an opaque treasure map to your intentions. Well, if not nonsense, then at least topics put forth with the purpose of distracting and dazzling your putative meal. If so, however, any noise would do, and you might as well say 'goo goo g'joob' straight. This seems too wide and fast. It is simply not the fact that in your interactions with art or people the nature of the verbal bits is always indifferent. "This is a child!" Haigha explains as a means of introducing Alice to the Unicorn. Had he said 'This is a serpent!' then things, we know, would have been different.

§102. Nor are the verbal bits always lieutenants or placeholders for ulterior motives. Reducing everything to an ulterior motive, and reducing intentions and deliberateness to ulterior motives, sounds excessive, as excessive as imagining that *everything* is always food-like, at all times. You may have a robust, walrusy motive, but then again you may have only vague expectations. Most

people don't want to eat their fish-quintets, any more than they want to kill and eat their interlocutors. The idea of tricking them into something does not even occur to them. They may have no particular plans in that respect. But this doesn't mean that they see it all as irrelevant nonsense.

§103. Perhaps we could say instead that a common way of addressing quintets and poems and paintings and even oysters is by promising to talk about all sorts of things. This is a way of doing justice to the fact Alice describes as having her head filled with ideas. To those unfamiliar with the process, some of those lists may sound like nonsense. And they may be so, though you will only know after the promise is fulfilled, or in the course of its fulfillment. To people unfamiliar with quintet talk, that is, to people who haven't been introduced to quintets or to the talk, some of the promises being made and some of the discussions being carried out could look thinly held together, and some of the topics would be made fun of and placed in a category together with whether pigs have wings. One's quintet talk is someone else's likely nonsense. Some of *your* discussions are often described in similar ways. In those cases you would probably feel that you hadn't been properly introduced and you would insist on a correction. Oysters and quintets, however, have no feelings, and so the correction of an introduction must be carried out in a different way.

3

A Mistake

(§§104–150)

§104. Many things are introduced, to you and by you. Talk is a common means of doing so. When you get your introductions wrong, a few of those things may complain. ("I'm *not* a serpent, I tell you!"). Most things, however, don't talk back. They are insusceptible of correcting their own descriptions. What you call art never remonstrates. Unremonstrancy, however, is not a sign of art. Oysters, atoms, places, and nonexistent people are in this respect just like quintets and poems. It is not only that they cannot talk, but that they are insusceptible of reacting to having been talked about in whichever way. Unremonstrancy is as unsurprising as any familiar fact. Were Knoxville to complain about introductory talk, or were the fish-quintet to develop rashes caused by verbal noises coming from human children, you would be surprised. What you don't expect from art is totally contiguous with what you don't expect from many other things. Dealing with art does not require that you change any of your humdrum assumptions about facts of nature. It is not a special dealing.

§105. Of course, you learn how to correct introductions of unremonstrating stuff, and often do so. Scientists do it, tourist guides do it, cooks do it, and the many diverse people who talk about art in many diverse ways also do it.

All would be surprised were talk to issue forth from their choice objects of concern. However, only *some* of those would be surprised at rash-like occurrences coming from the things they introduce. Unlike scientists, who have developed sophisticated expectations concerning rash-like occurrences, deliberately caused or not, that is, concerning what they call occurrences and experiments, and unlike cooks, who draw lessons from all sorts of curdling substances, art-talkers may seem more helpless. Nothing will ever curdle at their words or deeds. There are no occurrences or experiments in art in the sense that for you to know what is true you never have to *wait* for an answer. It is not, however, clear how you come to know what is true.

§106. Disagreement about how to introduce the fish-quintet is not a special kind of disagreement either. The problems it raises seem to be contiguous with problems familiar to many art-unrelated activities. If there is a difference between art-talk and other kinds of talk, if there is any feature that no other kind of talk shares, such a feature is certainly not the nonexistence of rashes, or the impossibility of experiment. And so art-talk is not a special kind of talk if by that you are to mean that the truth of its statements is ascertained in some art-like way. Perhaps instead you learn how to talk about art when you learn to correct introductions of unremonstrating stuff, for instance, to correct ways of talking about dead people, earthquakes, events, and perhaps of all things that you don't know how to make happen again. Someone who is good at speaking about those things will likely do well with the fish-quintet. And there may be an important affinity between speaking ill, or well, of the dead and talking about the quintet. Some talents required to speak about other unremonstrating stuff are of great help when you have to introduce the fish-quintet. This, of course, is not saying all or even much at all. Many interrelated questions remain. How, indeed, are you to correct an introduction, to correct your talk, when no experiments are possible? And how do you get to know that talk, your own or not, requires correcting? Are there any un-rash-like indications to be learned? It is expected that, as you become more familiar with the world of fish-quintet-talk, you also become acquainted with ways of addressing those questions. And you also are presented many, often incompatible, answers to them, and inordinate amounts of advice. There is, in fact, no need to imagine that such questions will allow for one answer only. They are not riddles. Nor is it helpful to say that they can be answered in many different ways, although that is likely to be the case.

§107. Sometimes when no experiments are possible you vote. In politics there also are no experiments and you sometimes vote. When you vote you don't know in advance whether a certain policy will work and you aren't allowed to try it on any smaller scale before you actually decide to vote for it; and so your vote expresses a rough opinion as to the general desirability or plausibility of a number of proposals, and perhaps also an opinion about those who propose to carry them out. Similar things said about the fish-quintet by different people are in some respects comparable to voting; they are rough endorsements of something that cannot be tried out on any smaller scale, both descriptions and endorsements of a certain description of the quintet, and often expressions of trust in the reputation of certain people. There may be a consensus as to how to talk about the fish-quintet based on a constancy of past talkings or at least on the similarity between quintet-talkings over time. Saying true things about the fish-quintet would not be anything special to be added to that consensus. This is because 'true' is there understood as what most people have thought the case is. If your dealings with the fish-quintet are to be understood only relative to any such consensus, then that is all truth is going to be for you.

§108. Imagine a party of wet animals wanting to get dry. And "they had a consultation about this." Any particular consultation might prove tempestuous and inconclusive, and you may not actually get to vote; but that is not what is most important. Two other things are worth remarking about—the first, that consultations are about what to do, in this case about how to get dry; the second, that there is no clear idea of what a consultation would be about in the case of art. The reason is that usually there is not much to do about art. Perhaps the idea of doing something *about* art does not belong in art-talk. And the notion of doing something about the quintet is not identical with the notion of talking about it. The notion of a consultation on what to do about the fish-quintet sounds idle; talking about it may not. And you don't consult let alone vote on *that* you hear the quintet either. It's not so much that you can't vote on the fish-quintet, as that you don't consult about it. And this is because the idea of deciding what to do next does not occur. You don't seem to know how to do anything *next* with the quintet. Thus a gathering of people for the purpose of talking about the fish-quintet may look like a consultation, but it really isn't. And a vote on the quintet, say when you award it the Oyster prize,

is not a vote about it. What would a vote about the fish-quintet be about? There is nothing for you to decide there, nothing for you to do about it.

§109. Perhaps you could consult and then even vote on what the fish-quintet really is. Animals somewhere assembled might wish to decide that the fish-quintet is really such and such and therefore that only those descriptions of the quintet as such and such are to be considered true. Perhaps they would do so because there had been in the past many incompatible descriptions, and some animals had become impatient. They might have imagined that determining what the quintet is would be like fixing something about the quintet, something that would lessen the proliferation of incompatible quintet descriptions. However, deciding what something is is not like getting dry, is usually not a course of action. Most likely, you still would not know how to act after a decision on what the fish-quintet is had been made. This is an important difference between quintets, poems, and dead people, on the one hand, and legal statutes, promises, and political resolutions, on the other. But then again perhaps the action, in the case of quintets and such-like cousins, could be to move on and decide about what something else is, and to do so methodically until everything that counts as art had been defined by the assembled animals. Art-talk would look like a grand survey of what everything counting as art is, through democratic or at least consultative means. However, at the end of all this surveying, after the final decision had been made about what the last thing counting as art really is, you would still not know what to do. This is, of course, because that is not what you do with art. There is something off about describing what you do with art as deciding, as there is with pursuing a course of action, and this is why the idea of a consultation sounds so idle. Voting is here just an extreme version of the very idea of a consultation, the extreme manifestation of an idle activity.

§110. However, you might argue that the reason the idea of a consultation sounds idle is because you imagine it as a council vote. Perhaps in matters of art what we call the 'voting' is something that happens over time instead, and in a more informal way. And only rarely do you make decisions or vote. It is instead the case that most people over time have thought the fish-quintet to be a wonderful quintet and have endorsed like-minded descriptions of it. After all, most people have endorsed certain unfavorable descriptions of Genghis

Khan over time. Those, however, we could say, are majorities of sorts, majorities in a different sense of the term. For one, you wouldn't be able to completely determine the size of the electoral colleges, nor would you be able to summon them up for consultation. And who would be allowed to vote in the matter of the fish-quintet? When would the polls close? Well, anyone born after the making of the quintet might vote, or perhaps only those who have "passed the proper examination." And would you have to be acquainted with the quintet in some way? If so, which way? At any rate, the members of the colleges would, in principle, be allowed to vote anytime. They should be able to go on voting forever, and to vote often and differently. Endorsing descriptions over time is more like a voting tendency, though in the case of art this would be a voting tendency without any actual voting.

§III. It is not only that there is something dubious about people voting more than once, and about the polls being always open. What is most odd is the very idea of deciding over time. Expressing preferences over time, as voting with your feet, is not quite what you call deciding—or voting. Nor is the expression of such preferences in most cases the result of any kind of consultation. When you choose to wear a certain coat repeatedly, or when many people buy the same book, they are not quite voting for anything, although the fact that something has been chosen or bought may indicate that it is held in high esteem by those who so act. Choices issued in such ways never precipitate into decisions. They are more like opinion polls than like voting. If anything, they express the scope of the various preferences of individuals, regardless of any notion that anything is to be done about such preferences. Instead, the point of voting is that it is simultaneous and limited: a finite number of assembled wet animals consult about how best to get dry and then take a vote. You could picture them as imagining the relative advantages of different courses of action. The Mouse believes that telling dry stories is a way to counter wetness. The Dodo later propounds a Caucus-race as a better remedy to the same problem. Should there be a vote, the vote would be in all cases *about* decisions. Perhaps you call long-term consensus voting essentially because you want to describe past choices in a unified way. You want to describe them as choices about the same issues, and also to suggest that they embody true verdicts. And you want to describe yourself as part of that consensus. To those who so favor the notion of consensus, the verdict of the ages, in fact, always inclines to truth. There may, however, also be constancy in

error. A majority of people may be wrong over time. Anyone might be wrong, not just about unremonstrating quintets but also about unremonstrating planets, and even about remonstrating people. That most people think something is the case only shows that most people think so. And in most cases, 'most' only means the majority of those who said so.

§112. Perhaps quintet-talk should be defined instead as a series of asynchronous, and often contradictory, preferences expressed over time. Puzzled observers frequently remark that there is no "One, two, three, and away!" to art-talk and so that, unlike fishing or football, there does not seem to be any special season, and, unlike elections, certainly not a polling season, for preferences to be expressed. Puzzled observers have often talked about art-talk as you would talk about the Caucus-race: "They began running when they liked, and left off when they liked, so that it was not easy to know when the race was over." In art-talk it is hard to say where to begin, where to end, and who has won. As in the Caucus-race, you often have the impression that "*everybody* has won, and *all* must have prizes." Now if everybody has won, the point of the race doesn't seem to be in the winning. And there is no decision as to who has won.

§113. There is, however, an important difference between the Caucus-race and art-talk. Asynchronous and chaotic as both may seem, the former appears to have a point. The Caucus-race, the Dodo says, is "the best thing to get us dry." You do it because you want to get dry. "When they had been running half an hour or so, and were quite dry again, the Dodo suddenly called out 'The race is over!'" If art-talk were to resemble the Caucus-race, it would be the race without its point, without anything like the equivalent of wanting to get dry, even if of course its participants might still get dry in the process. But then getting dry would be an unintended, however welcome, consequence of art-talk. The point of swimming a 200-meter butterfly is not to get wet or to gain new insights into life, although the former will happen necessarily and the latter might happen occasionally. But you could say that a Caucus-race without a Caucus-race point would not quite be a Caucus-race. It would be like chess without a checkmate.

§114. So we have a series of related activities: voting, consulting, running the Caucus-race, and running the Caucus-race for no common reason or many particular ones. Art-talk is something like voting, and is something like

consulting, and is something like the Caucus-race, and is something like a pointless Caucus-race. You want to describe this animal by comparing it to the more familiar beasts. Toves, Humpty Dumpty explains, are "something like badgers . . . something like lizards—and . . . something like corkscrews." "They must be very curious-looking creatures," Alice remarks. "They are that," Humpty Dumpty agrees. Art-talk is curious in a similar sense. Sometimes you recognize the badger, but then you also see the corkscrew. Perhaps this is because art is something like badgers, something like lizards, and something like corkscrews.

§115. But surely it seems excessive to suggest that there is no point common to all fish-quintet-talk, no goal that every participant shares or must share. For one, they all in some way talk about the fish-quintet. However, this is the sort of explanation that cannot be expected to do much work. The impression often is, and not just among impatient animals, that fish-quintet-talkers are talking about different things and even doing different things. And so people often complain that talkers don't mean the same by 'fish-quintet,' or that what they call 'talking about the fish-quintet' is understood differently, or even complain that they would describe what they are doing, what they otherwise call talking about the fish-quintet, in vastly different ways. This seems to indicate that you are often confused and disagree about what the facts of the matter are, and both relative to words and actions. It may look like a quintet-talker is talking about the fish-quintet, but that person could describe it as altering the quintet, making a statement about something else, securing a job, or making fun of someone. And, of course, quintet-talkers often describe the quintet differently and endorse different descriptions of it; and they sometimes identify the quintet in vastly different ways. That the quintet is there for you to see, or hear, that it is what you sometimes, for short, call a 'thing,' which no one seriously doubts, is of surprisingly little avail. The experience of making a description follow from those incurable features of quintets, features they share with their cousinly fish, may be as exasperating as that of pointing to a star with your finger. We want to say that the pointing is never enough. It takes talk, and it takes time, to know what you are talking about, what you are doing, and whether you are making any sense. And so there is no real difference between pointing to and talking about. Pointing to is no preliminary sensory ablution on whose shoulders all subsequent talking about would need to stand. Forefinger antics are often part of talking about.

§116. Even if there is no one common goal, each participant in the quintet-talk race may still have goals, often very specific ones. Some might want to get dry, some might imagine a victory, some might want to get it right, and others might just want to get something across *and* to get dry. Imagining art-talk as a distinct activity or even as a set of related activities is the sort of mistake you make when you describe a crowd moving about a busy city street as engaged in a particular sort of ceremony, for instance, a race. To be sure, the sight of a crowd moving in one direction looks something like a race. And putting cough syrup to your mouth with a spoon looks something like eating. Identifying art-talk with a race amounts to construing concomitant goings-about as the product of concomitant deliberateness. You describe people as having similar goals just because they happen to be doing roughly what you identify as similar things, as if goals were always to be discovered through choreographic inspection, an inspection of bodily movements. The idea of concordant verdicts over time, and so the very idea of indefinite polling, is also part of the same way of explaining things, as if the fact that many people have thought the quintet wonderful would mean that they would all be moving in one direction and thus indicate anything about something independent from their verdicts. You draw a list of occurrences, of animals saying things like 'wonderful,' while pointing to the quintet, and you conclude that they are all doing the same thing. They need not. After all, it is possible that only a few people are moving down the street for the same reasons. The impression that they are all making the same kind of noises about the quintet often vanishes upon nonchoreographic inspection.

§117. So, in matters of goals at least, art-talk is not like the Caucus-race. Rather, the similarity appears to have to do with how participants in both activities can enter them and leave them in ways that may seem incomprehensible to outside observers. And this is because anyone may begin running when they like, and leave off when they like. Regardless of their goals, in both Caucus-race and art-talk, the participants appear to be doing something because and insofar as they like it. People appear to like art-talk at least as much as they appear to like art. Thus assume that you will do it for a number of reasons, but always because you like it. Does this, then, mean that art-talk can only be evaluated and described relative to individual likings? A liking may resemble a spasmodic, and a very short-term, goal. Or it may determine the threshold or the scope of a goal, something like a cause or perhaps a condition.

Why do you talk about the quintet at all? And why do you talk like you do? You could say that you talk, and talk the way you do, because you like it. And so, presumably, you change talk when your likings change. Since the cause of your talking is your likings, your goals are contingent upon them: you will only have goals insofar as you have any likings. Thus for anyone to know your goals they would only have to worry about your likings. Likings, however, cannot be inspected directly. To a certain extent you might attempt to extrapolate from choreographies. After all, you more or less know when someone else likes something.

§118. But you may wish to insist that the fact that you like something is in an important sense your own business and something that should not be open to inspection, choreographic or otherwise, by others. The causes of your running the art-race are so much your own that they must be available only to you for inspection. You may believe you are your only possible inspector, and one that will always vouch for whatever goes on with you. If this is the case, then perhaps there is not even the need for an inspector. This saves a world of trouble. When you art-talk, it must be because you like it. And when you leave off, you must have ceased to like it. There is nothing for you or anyone to explain. Talk for you is a rash brought about by your likings. You like, you enter the race, and you talk. And art-talk is just a case of talk.

§119. This would at least explain the notion that all must have prizes. All must have prizes because prizes refer to goals, goals are determined by likings, and all have likings. The notion of a prize in a race-like activity has to do with the idea of doing something well. If the idea of doing something well is to be determined by the idea of liking what you do, and if you only do it while you like it, then *that* you do it must mean that you do it well. No wonder you always deserve a prize. And since you are the one doing the inspection, you award yourself the prize. You vouch for yourself. No wonder you always *get* the prize. The sense that you deserve and get a prize in these matters is closely tied to the sense that your likings are your own to have and so at all times the best possible likings. Surely you wouldn't enter the race if any other different and more powerful liking had been available to you at the time. You are awarding the Oyster prize not to the quintet but to the causes of which quintet-talk is both symptom and effect.

§120. Is vouching for yourself, however, a case of vouching? It sounds like endorsing your own feet, or your thoughts and beliefs, like voting for what you already have anyway. And it is like asking in court where the tarts are when the tarts are "in the very middle of the court." You might call it an endorsement, except that vouching for yourself is never a possibility open to debate or decision: it is what happens anyway. There, indeed, is nothing for you to do or know, no equivalent to the specific course of action you might follow in order to get dry. You don't consult and then vouch for yourself, and of course you don't vote. Nor is there a way for you not to endorse your own feet or thoughts. Vouching for yourself in matters of art-talk simply means that you like your likings. That you always rather do. Nor, for that matter, is the attachment to the idea of a prize like the unjustified continuance of a custom, persisting despite the fact that nothing would depend on it. Nothing, in fact, has ever depended on it. There was no time in history when your likings were further away from you than your feet or your thoughts. The emphasis on this idea of a prize comes instead from imagining that art-talk is part of some kind of competition, some kind of race. And as you see that such a race could only depend on your likings, you tend to imagine art-talk to be part of a caucus-race, a race that you can enter and abandon when you like. You want the sense that all quintet-talkers are doing the same thing, that all animals are running, and that all quintet-talkers depend on their likings, and that animals are only running while they like it. You want, in short, concurrence in goals and autonomy in spasms, a crowd moving down a street, and one wholly animated by likings.

§121. In art-talk you always win, but since you're only competing with yourself, you also always lose. When you award yourself the Oyster prize, you are also celebrating your own defeat. At least in this, the original Caucus-race is just like art-talk. Prizes are like the tarts in the court; they have always been there the whole time. If art-talk is up to your own likings, many things about it will also be tart-in-court. What art is like and what counts as art will be tart-in-court.

§122. There seems to be a mistake somewhere in the notion that in art-talk you always win. The mistake is a compound of two different notions. One is that you always vouch for yourself. This if laboriously only indicates that you are yourself. If you learn it at all, you must have learned it by the time you

learned how to vouch. There is in it nothing specific to art-talk, like a wish or a belief that would only surface in matters of art. And vouching for yourself is neither wish nor belief, otherwise it would be either a wish about something about which there is nothing to wish or a belief that would be permanently true. The second notion is that you may also see the vouching as a decisive, tie-breaking vote. You also believe that being yourself is the ground for further action, namely, action in the context of some race, as if being yourself would prove advantageous over the fact that all others are also themselves. Unlike the first notion, this second one is more like a wish or a belief. Perhaps you wish for your vote to be the only vote because you believe you are who you are in a special way. In short, you wish to win a tart-in-court race. When you do, you believe that even if all must have prizes, not all prizes will be equal. Fury the dog curtly explains it to the Mouse: "I'll be judge, I'll be jury / . . . I'll try the whole cause, / and condemn you to death."

§123. Anticipating perhaps its own fate, the Mouse sees this as a "sad tale." It is also a mistaken one. What makes the sad tale a mistake is not so much the belief that no one else has the right to vouch for you, which is relatively inconsequential, as crucially the fact that you believe you can be judge and jury. You may believe that your talk cannot be corrected by anyone else, just as your likings are ground enough for it, but you also believe that there is something to your talk that makes you judge, and jury, to everyone else's. That you always award the Oyster prize to yourself is humdrum. That you deny humdrumness to others may only mean you believe there is something special about the way you are yourself, independent from how special everyone else thinks they are. And not everyone would agree. Beliefs about the quintet are tart-in-court. In this they are just like any other belief. But they may also be judge-and-jury. If you have judge-and-jury beliefs, you believe the only legitimate beliefs about the fish-quintet are the ones you hold. Nothing else counts.

§124. The Mouse talks back to Fury. A trial without a judge and a jury, he submits, "would be wasting our breath." By this he means that no one, and certainly no dog, should be judge and jury. As long as it is all about Fury, you may sympathize with the Mouse. Is there, however, any hope of modifying the canine judicial system and finding a judicial way out of all these problems? Perhaps it would be possible to imagine a court where matters of

quintet-talk might be decided on the merits of the talking, or the quintet, or some talk-to-quintet "fit," rather than on any inspection of likings or judge-and-jury protestations. Some of the added ferocity of the dog's suggestion comes from how he sees his judicial interests and motivations: "We must have the trial," he explains, "For really this morning I've nothing to do." Going to court may look to him like occupational therapy, perhaps like a blood sport. There seems, however, to be a connection between how the dog decides to "go to law" and how he decides he will be judge and jury, an affinity between his wrong motive and his unrequired decision. For one, they are both about his likings. And, of course, the Mouse suggests that there is more to a court of law than the weight of a dog's likings. There are rules, he seems to think. And surely rules are independent from likings. There may be, presumably, respectable motives for going to court, but liking it is not among them. That you might like to have a trial is neither necessary nor sufficient, neither here nor there.

§125. The question remains, in the case of art-talk, of what the respectable motives for going to court would be. You might think matters of ownership, matters of property, or matters of rights. You might feel that you own the quintet, or that someone doesn't own the quintet, or that no one can own the quintet. But this is not specific to art-talk, although of course art-talk may be part of how you reason about it. An art-talker may be summoned to court to say things about art that will then be used as a premise for some art-unrelated conclusion, for instance, a conclusion concerning what to do *about* art. A fish-talker may be summoned to perform very similar tasks in relation to fish. Both may state that because such and such a thing is such and such, such and such consequences might follow. This the fish-quintet shares with fish and many other things besides; they all belong to the generic rough class of things you talk about when you ask yourself questions of ownership, property, or rights: things like fish or quintets or actions, perhaps not things like stars or moral dilemmas or numbers. Even before you consider any measures to eradicate doggedness from courts in matters of art, you will have to imagine first what a court deciding about stars or art or moral dilemmas would be like. You may want to solve matters pertaining to such things, and you might want stated that a given thing is such and such rather than that something follows from something's being such and such. Nevertheless, would a court, *any* court, however dogless, be the best way to do it?

§126. You may feel you sometimes need help with the fish-quintet. Perhaps you are impatient that you are getting contradictory opinions and advice and definitions elsewhere or everywhere. And in the case of quintets, though perhaps not in every case, the sense that there is no point in waiting for the truth, which is connected to unremonstrancy and the impossibility of experimentation, may add to that impatience. And then you might imagine that help would come from a court decision. There is a connection between knowing that in certain matters the truth is not a question of waiting for it, and your hopes for a court decision, your hopes for some kind of court that would help you in getting the matter settled, by sentence as it were. But here of course it is not so much that you feel that injury has been done to you, to your property, or to your rights as that you don't know what to do about certain things, or that you are unclear as to what certain things are. Despite being intimate with your likings, you have perhaps realized that so is everyone else. You then hope for guidance and help to come under the form of justice and, crucially, for justice to be ministered by a court. This is why you imagine fish-quintet courts or art-courts. You see help, and being helped, as a form of justice, and you see justice as a solution to the likings predicament. But surely you also must still harbor the hope that the judge and the jury may somehow do justice to your likings, that they will like them. You may resent canine justice but have not completely given up canine hopes. Canine hopes in dogless justice, however, are like believing you will win the lottery.

§127. You may hope for a dogless court as much as you like, complain about canine courts, and about how court rules are not being followed, about how dogged other people are being about your likings. But what you are hoping for cannot perhaps in the end be provided by any court, that is, might well not be able to be provided in any noncanine way. Indeed, you want no less than for your likings and beliefs about the fish-quintet, which, for short, like everyone else, you call fish-quintet, to be vindicated. Note that you do not want to have justice made *about* the quintet. Art-talk is required by the fact that you don't know how to do justice to things like quintets, not by the fact that you need somebody else to decide what such things are, let alone whether they are, for example, real things, so that justice can be then made. This is not what we call justice. No injustice has been committed to speak of, in the sense that there is no injustice in that you haven't won the lottery. The fish-quintet, like your losing lottery ticket, has not been added on to the world, or at least can-

not be seen as a particular distortion thereof, like a crime or a wrong. Rather, the quintet is what cannot be eliminated from the context in which you ask for help. It is there. And so if you insist on going to court about the quintet, you don't go to court looking for something that isn't there already, or hoping for a state of things from which something will be removed. Your hopes are not hopes for remedy. The justice that is to be done is already, tart-like, there. Concerning the general question of justice-to-quintets, then, the only thing that can be done is to follow the King's example and point to the tarts on the table. This is not doing much, and is certainly not doing what you want. The fish-quintet—no less than you, the judge and the jury—is always tart-in-court.

§128. The alternative to the canine mistake of imagining that everything can be left to your likings, to your judge-and-jury inclinations, the mistake of imagining that your likings are different in kind from everyone else's, seems to be the murine mistake of imagining that art-talk needs to take a judicial form and has to be built through legal procedural means. By transferring your hopes to such means, you will likely insist that a solution has to be produced from evidence, and also that once that solution has been produced, something has to be done. You hope to go from evidence to verdict to sentence, and you also hope that, once a fair sentence has been issued, your problem will disappear. And, for you to do that, you need a sense of procedural rules. Such rules concern the inferential chain leading from evidence to justice. But rejecting canine courts in matters of art, as in matters of general justice, need not imply accepting that matters of art, unlike matters of general justice, are to be solved by means of noncanine courts. You don't have to play dog-and-mouse.

§129. If you insist on having a court, it would have to be a court to deliberate about something tart-like. In such a court there could be no strict separation between judge and jury, as there is no strict separation between you and vouching for you; and so no relevance to the distinction between guilt and innocence as you both win and lose the Oyster prize, no strict difference between what you claim to see and what you don't see, and nothing to discover or even establish. Thus doing justice would not be a matter of following any procedural rules, or a matter of attending to evidence. In your art-court there would be no room for inference. In short, an art-court wouldn't be anything like what you call a court, anything like what you had hoped for.

§130. Granted, you may begin, and perhaps you must begin, from the sense that something is amiss, and so from something resembling an indictment. The quintet, you might claim, has been hijacked by some other canine quintet-talk. "The Knave of Hearts," you may feel, "he stole those tarts / And took them quite away!" And still, and as always, "there they are!" "Nothing can be clearer than *that*." Like Alice, no matter how confused you might be about the quintet, you still begin from some sense that "*somebody* killed *something:* that's clear at any rate." Art-talk likely begins from the sense that something you deplore has taken place, and also that something needs to be set aright. It also may begin from the sense that you need to do justice to something that is as much about you as any of your feet, thoughts, or beliefs. But neither is properly like a crime or an injustice. Both are more like not having won the lottery.

§131. The evidence for something's having happened, for somebody's having killed something, is not independent from the position in which you find yourself or from what is about you the most. To describe that position you would have to include the tarts on the table concomitantly with their abduction and your wishes, likings, and beliefs. What you mistakenly take for an art trial always begins in one and the same way: "In the very middle of the court was a table, with a large dish of tarts upon it: they looked so good, that it made Alice quite hungry to look at them—'I wish they'd get the trial done,' she thought, 'and hand round the refreshments!' But there seemed to be no chance of this; so she began looking at everything about her to pass away the time."

§132. Alice's hope for the refreshments to be presently handed round is hope for immediate access to the tarts. Everything would be much simpler if people would only realize that it is all art-in-court, and so no trial is required. Alice's hope expresses the wish that "pointing to the tarts on the table," like pointing to your likings, would be remedy enough for the matter of the stolen tarts. And her hope is echoed, in equally sanguine, if perhaps bloodier, ways by the Hearts. The King repeatedly tells the jury to consider their verdict, regardless of any evidence; and the Queen, who has the deserved reputation for being dogged about what she knows is the only possible outcome in all matters, memorably expresses her legal philosophy as "Sentence first—verdict afterwards." 'Hand the refreshments,' 'consider the verdict,' and 'off with their

heads' are in their three different idiolects expressions of a similar wish for a kind of justice based on unmediated access to the facts of the matter, justice that needs only the sense that something is amiss, and the notion that something is unconditionally available. This is the hope that better describes art-talk.

§133. The Caucus-race impression that you often get from art trials has to do with the fact that similar wishes are concomitantly, if asynchronously, expressed by different people in different idiolects. And so it is part of the tart-trial that you raise procedural objections concerning the expression of other people's wishes. Tart-talk is substantially about that. When the King first suggests that the jury consider the verdict, the Rabbit interrupts him: "Not yet, not yet! . . . There's a great deal to come before that." The King may wish to be judge and jury, but only after the Rabbit's dead herald body. And when he tries it "for about the twentieth time that day," he is interrupted by the Queen: "No, no! . . . Sentence first—verdict afterwards." And when the *Queen* says so, she is interrupted by Alice: "Stuff and nonsense! . . . The idea of having the sentence first!" It is not so much that the Rabbit, the Hearts, and the Hearts and Alice have different notions of what the procedural rules are, and incommensurable notions at that; none seems to be after any decision that would put such a disagreement to rest, and besides, the rules are never on trial. Rather, they are all expressing the same wish. In their own different ways they are all hankering after the refreshments.

§134. This is only saying that they are all attempting to do justice to what for each of them is the *point* of the trial. And so it is still possible that the trial may not be about the same thing to every participant. It matters little what kind of tart, and it matters little what individual piece of tart. What the different parties identify as an individual piece of tart, for instance, the fish-quintet, may well prove irrelevant. Instead, the parties will attempt to find a way to do justice to their beliefs about what matters, about what the matter is. Claiming to know the procedural rules in art-in-court trials, claiming to know what must come before and what after, is not to express any opinion about rules, let alone about justice or inference. It is to cry dog at others' attempts to get at the refreshments. Such a negative animus is not due to art cynicism. Rather, tartness emerges out of the impatient sense that you need to do justice to something that is already there. Since the awareness that something is

patently there brings with it the added sense of being judge and jury on those matters, you may naturally wish to eliminate any other parties to the dispute. *That* you see the quintet seems to make it unnecessary for anyone else to do it. And if you claim that how you talk issues from that you see what you are talking about, you may safely claim to be judge and jury in tart matters. Since so may everyone else, however, there never is any chance for you to get away with it by merely invoking your access to the facts of the matter.

§135. Not to belabor the obvious, but what you call an art-court is not a court. Imagining that art matters are disposed of in judicial ways is a mistake, a mistake comparable to that of expecting your own perceptions or beliefs to be vindicated by sentence or vote and a mistake twin to expecting your perceptions or beliefs to be true or accurate simply because they happen to be your own. These are all forms of the same mistake. If you insist in seeing art-talk as court-talk, you will cry Caucus-race, as you will be appalled by "the way all the creatures argue," and appalled by the fact that large numbers of people worry about who stole the tarts when the tarts are very obviously there for you and so presumably all to see. But then perhaps you are missing the point by relying too much on choreographic inspection. Turning quintet matters into matters for judgment is again describing the proverbial city crowd as engaged in some race or ritual, even if you can never admittedly describe what the purpose or rules of either of these would be. You hope for tart-courts to be as "common and uninteresting" as the more familiar courts; then you gradually realize that everything there is "as different as possible"; it is little surprise that you conclude that they "don't . . . play at all fairly . . . and they all quarrel so dreadfully one can't hear oneself speak—and they don't seem to have any rules in particular." But perhaps your hopes have been mistaken all along.

§136. Instead of assuming that the things you do are either legal or mad, either Mouse or Fury, you should assume instead that, at least in the case of art, having all things rely on such disjunctions may show that your analogies are wrong. Introducing art, talking about art, is not a game, a race, and not even a Caucus-race; nor is it a matter for the courts, for consultation or voting. It assumes unremonstrancy but is also not wholly up to you or anyone else; art matters are not decided by perception, likings, rashes, judgment, or votes. And yet versions of these all appear to play a role in what you want to describe. And none of this necessarily implies that art-related matters are a

dream or a form of madness. You need to be able to describe fish-poems and quintet-talk relative to, and coextensive with, tart-in-court quarrels and insistences on incorrigibility, relative to other people, yourself, things that matter, and things you do because you have nothing else to do.

§137. Just like people who concomitantly walk down a city street, people who go about talking about art to one another are often thought to be mad in similar ways. But perhaps the sense of such a similarity comes from your reliance on superficial choreographic means. The description of quintet-talking people as mad is superficial in this sense. What is superficial is imagining a common ritual, even a common life or a common cause, instead of attending first to the reasons, hopes, wishes, and beliefs of art-talkers, which may or may not be common to other art-talkers. Ritualistic explanations are most often put forth by people to whom certain practices are utterly incomprehensible. They are, at best, required when you want to suggest that something familiar may not be anything natural. And so there seems to be precious little hope of reconciling descriptions of quintet-talkers as mad people all doing similar things, which are characteristically put forth by non-quintet-talkers, with descriptions of quintet-talkers as people, sane or not, doing many things that can only be superficially described as similar, which are characteristically proffered by quintet-talkers, or perhaps art-talkers. If art-talk is to be described by outsiders, art-talkers will be described as all mad, and art will often be defined as that very similarity in madness, as a mad ritual. If art-talk is to be described by insiders, other art-talkers will be accused of being judge and jury and non-art-talkers will be accused of being ignorant. And everyone else will be accused of not being entitled to do what they do.

§138. "How do you know I'm mad?" Alice asks. " 'You must be,' said the Cat, 'or you wouldn't have come here.' Alice didn't think it proved it at all." Indeed, it doesn't. You need not be mad to go to mad places, any more than you need to be a Knoxville native to go there, or to become a resident, let alone a native, when you go there. People go to mad places, and sane places, and Knoxville all the time. They may get there by chance, by mistake, or deliberately, and also because they may want to get somewhere else or because they may be after something else (say, following a rabbit). They may have intended to get there because they had heard things about the actual place, or about an activity. They may have felt curious about a place where people introduce

quintets, or abstain from buying bourbon on Sundays. They may have come across a quintet-talker in civilian life, and she may have struck them as odd. And they may intend to remain in Knoxville for the rest of their lives. When the Cheshire Cat says that "we're all mad here," this is just a judge-and-jury description, and so still liable to the standard objections against Cretan cats. Perhaps art is instead in a very important sense about people approaching people doing certain things, talking in certain ways, for example, introducing quintets left and right but also in an equally important sense about not necessarily being like them. Put this way, so are countless other things. But, then again, perhaps art matters are also in this respect like countless other matters.

§139. Of course, in one respect at least art-talk is unlike being in Knoxville or anywhere. And this is because going about introducing quintets usually coexists with many other activities, whereas being somewhere is more of a despotic affair. The impossibility of ubiquitousness does not seem to play any role in art-talk. Talking in certain ways or doing certain things is not much like being anywhere. And you will never be anywhere by coming to talk in a certain way. Nor will you become to the quintet born, or born again, unless you see yourself as being simultaneously in Knoxville, Tennessee, and Knoxville, Sweden. In fact, you quintet-talk but also do many other things besides, none of them quintet-related. No one will only art-talk. That would be mad.

§140. There is a difference between the person who describes people as making roughly comparable noises or making identical movements, the person who relies on choreographic inspection, and the person who eventually becomes capable of making distinctions between such noises or movements, for instance, the person who no longer sees them as roughly comparable or identical, the person who does not rely on choreographic inspection. That you approach people often makes you change your mind about what people are doing, though of course this does not require that you do whatever they are doing. Approaching people often means losing the ability to see what they are doing as contiguous or identical to other people. You forget that Haigha was once the Hare. Unfortunate place-talk is also in part brought about by describing those changes as the result of *approaching* certain people. You may mistakenly conclude that there must have been something about your new position that caused that change. This is seemingly confirmed by the fact

that very often you quintet-talk only in certain places (you quintet-talk in quintet-school, in quintet-hall). And so you conclude that there must be something about those places that causes you to talk in certain ways. But from that you talk in certain ways, it doesn't follow that your talk is in any way determined by a place or a position. There are no tart-emanations to determine anything, and so you do not become infected by feline madness by being somewhere.

§141. Approaching people, then, is not necessarily the action of moving closer to anything, anywhere, or anyone. It may not even be what you normally call an experience. For instance, you do not learn to discriminate individual purposes in any finer way by immersing yourself into a crowd. You can't immerse yourself in the past. And you may taste the tart and not taste any tartness in it. You may read the poem and understand nothing about it. Some people have approached other people in the privacy of their own minds. Others have moved to Knoxville. None became closer to anything by going or not going anywhere. You may have moved to quintet-school in Knoxville in the hope of becoming closer to quintet-emanations. But since there are no emanations, you may have moved in vain. Your hopes may be fulfilled in all sorts of ways. You may approach people in all sorts of ways.

§142. But surely there is something like approaching someone else, coming to someone else, for lack of a better term, in the right spirit? Perhaps it is the spirit in which you do what you do, even if you don't move, that characterizes what you do. You may certainly have come to the Cat because you had hopes, and had deliberately acted on them. You may have heard about the Cheshire-school, and were perhaps curious. But you may have had hopes *and* no idea of how to act on them. And you may have come across the Cat quite by chance. Having certain hopes is similar to being in the right spirit. But you might not have had any hopes in particular, and have just gone for a walk because on that morning you had nothing better to do, and still your life might have been changed by something or someone you might have come across. And your hopes, what you call the right spirit, might have been disappointed, modified, or surpassed by your interactions with the Cat, in Cheshire-school. When you are disappointed you realize that having hopes was similar to wishing for the tartness of the tart, insofar as no amount of moving or no particular action seemed to alter your ordinary judge-and-jury approach. Being in

the right spirit is at times like a wish, in that it makes you act, and like a belief, in that it makes you look around for evidence. And yet you can be in the right spirit and still be judge-and-jury.

§143. This is because being judge-and-jury is not a function of being somewhere, and certainly not anywhere special. No description of any place will explain the fact of judge-and-juriness. And being judge-and-jury is not a function of saying certain things, and certainly not of speaking in certain ways. No description of ways of speaking will help characterize judge-and-juriness. 'They're all mad' is no less or more judge-and-jury than 'We're all mad.' The mistake of being judge-and-jury, like the mistake of hoping for a judicial solution to your quintet-worries, can happen anywhere and express itself in any number of ways. When you say that the crowd going down the street is performing a ritual, the fact that you are not part of that crowd does not make you more or less able to capture the putative harmony of each person's deliberateness. Rather, being judge-and-jury is what happens when you assume incorrigibility from unremonstrancy, when you assume that, when there is no remonstration, whatever you say goes. You assume that in the absence of any rashes the facts of the matter are up to you entirely. This is similar to believing that any decisive evidence for the existence of God requires miracles and then declaring that there are no miracles. You believe that since quintets and poems and crowds do not break out in rashes, it is up to you to be judge and jury on such matters. To make up for certain shortcomings elsewhere you put yourself forth, fully equipped with your likings.

§144. If you won't hope for more than your likings, you will feel no need to approach other people, let alone develop anything resembling the right spirit. If you like the fish-quintet, no one else, not even anyone else liking it, is worth approaching. And this is because you believe that by liking the quintet you can develop in yourself the rashes that you miss in your poems and quintets and fellow-quintet-listeners. Believing that you can make up for certain shortcomings about the quintet means believing you can make up for the quintet's unremonstrancy. It is not just, or not necessarily, that you correct the quintet or the poem but that you actually believe that the quintet or the poem causes *you* to correct them. Judge-and-juries trust tart-effluvia, provided these are directed at them. And they see no need for tart-school. If everything is up to your own spasms, then nothing is to be acquired anywhere. You

don't have to attend shiver-school, or perspiration-school. All that is neces-
sary to art is about you at all times. Of course, so it must be about everyone
else. And as you engage in this task of redeeming unremonstrant poems, so
does everyone else. And you all believe that you are getting the right effluvia.
And, of course, you may all be mad.

§145. That you have approached other people in matters of art can be expressed
in a number of ways: through claims about places you've been to, through de-
scriptions of the people whom you have approached, perhaps memories you
have of them, and through all sorts of certification. These all may look like
non-judge-and-jury ways of explaining who you are, but they really are just
claims according to which who-you-are is not judge-and-jury, that is, claims
according to which who you are is owed to other things, including the people
whom you have approached. That you have approached other people is often
expressed as you would express your debts. But at the end of the day you may
still remain judge-and-jury about your various claims and expressions. You
may easily be judge-and-jury about your debts. Since being in debt is not up to
you, claiming that you are will not change the fact that you are. Owning up is
not paying up. It may be important preparation to paying up, but then again it
may not. It is not the fact that what you do may indicate that you will momen-
tarily be doing something else that will count as your doing something else. A
promise may be broken, and an indication may be idle.

§146. You often describe having approached other people as having been to
school. Your life in art would retrospectively resemble some form of precisely
timed experience, like a syllabus. Claiming that you have been to school may
sound like a claim about having been somewhere, but of course the school you
mean need not strictly have been a real school, and so you need not mean that
you have been anywhere in particular. You may simply mean that you have
come to know something, and also that you have learned it somehow, from
someone, and call it all a school for brevity's sake. "I know all sorts of things,"
Alice claims. She means things like Multiplication, Geography, and Poems,
that is, things that are often learned in real schools, or at home. But she also
means things like going about knowing whether you have "changed in the
night." These are perhaps learned, but they need not be learned anywhere in
particular. And you may claim besides that by having approached certain
people you have become a certified something, such as a certified poem-talker,

or a certified quintet-maker. The Red Queen reminds Alice that she has no right to *be* a Queen, and so to call herself one, until she has "passed the proper examination." This suggests that there are non-judge-and-jury ways of showing who you are, even if your claims about such ways may still be judge-and-jury. In fact, when someone disputes your claims, you may have to do more than just show a certificate. Showing a poem-talking certificate will only take you so far. What they really want to know is if you can poem-talk. And if you can't, they will not emendate the certificate but instead change their opinion about you, since of course the trouble was not with the certificate but with your claim. Finally, you may also describe having approached other people as having become acquainted with people from whom you have learned some of the things you know. In that case you will not so much show certificates or talk about places as, most likely, you will talk about people. "When we were still little," the Mock Turtle reminisces, "we went to school in the sea. The master was an old Turtle—we used to call him Tortoise." For the Turtle, the fact that he has been to sea-school is perhaps less important than that he remembers his master. "We called him Tortoise because he taught us," he adds. You will remember your masters and sometimes you will call them your masters only because you remember them. Of course, from your masters you may claim to have learned multiplication or poem-talking but also very often things "not taught in lessons," such as manners. Of all people, Alice remembers the White Knight, Master Tortoise-style, the best: "Years afterwards she could bring the whole scene back again, as if it had only been yesterday." And you have the sense that she has learned something from the White Knight. Everything about the Knight "she took in like a picture." But claiming that you remember someone, like claiming that you owe something to someone, is still somehow being judge-and-jury about it.

§147. Surely the important thing is not that you have been somewhere, or remember someone, or hold a certificate. Could it be that you have acquired something, perhaps something palpable like a tart? What you call knowledge, knowing something, you often imagine as something in this way palpable. Alice primarily claims that she knows Division, her ABCs, French, and Music and also knows that she, unlike the Mock Turtle and the Gryphon, doesn't know Washing, or Mystery, or Laughing and Grief. And what you have come to know, even if it was learned, may not have been taught through lessons, or even taught at all. "Lessons," Alice says, "teach you to do sums, and things of

that sort." But claiming that you know something is in this respect similar to claiming that you hold a certificate, have been to certain places, or have met certain people. You advertise for a belief and in the process propose to vouch for yourself.

§148. Alice approaches various creatures, mad or sane it matters little. That she approaches them doesn't mean that she goes anywhere, let alone somewhere special; nor does it mean that she gets to know them or even, Master Tortoise-style, remember them; she may, but then again she may not. And it certainly doesn't mean that she gets a certificate in the end. So what is the content of "the whole scene"? What is it that you take in "like a picture"? You don't take in knowledge, if by that you mean something independent from a scene or something that could have been acquired by other, more direct means. In quintet-school you don't simply learn about quintets straight. And rarely will you claim, and then always judge-and-jury, that you know poems or even that you know how to speak about them. These claims tie in with claims about your various dealings with many other unremonstrating things, and remonstrating as well. There is no preestablished wallpaper to the poems you know. Art may be in court for all to see, but you never walk away with a piece of it, a piece of knowledge that you may call your own, regardless of everything else.

§149. This is why you often have to describe "the whole scene." What you call 'knowledge of art' is such a scene. But a scene cannot be described as something that matters, say art-knowledge, surrounded by a number of things that matter less, optional props that provide knowledge with an atmosphere or a local color. "The mild blue eyes and the kindly smile of the Knight" is not superadded atmosphere to Alice's knowledge. Nor is it a consequence of that knowledge. The such and suchness of the Knight is certainly relevant to her having taken him in like a picture. The Knight matters to the picture, and matters to the extent that it wouldn't be accurate to say that the picture is about something to which the Knight has been added. You wouldn't say that the flavor has been added to the coffee, or that a person has been added to an emotion or a memory, or a wall to a room. Alice's picture includes the Knight, his eyes, his smile, "the setting sun gleaming through his hair and shining on his armour," a grazing, moving horse, the reins, "the strange pair," "the black shadows of the forest behind," and, not least, a "very, *very* beautiful"

sung poem and "the melancholy music of the song." It includes her leaning against a tree, "with one hand shading her eyes," watching and listening. It includes, just possibly, their infuriating exchange about the difference between 'the name of a song,' 'what you call the name of a song,' 'what the name of a song is,' and 'what you call the song.' The whole scene may include people, nonexistent or not, places, things, the slightest notations sometimes, and yourself. It may include anything.

§150. Describing the whole scene is to some extent describing a bit of your life. But this doesn't mean that you always set out to organize the wallpaper so that everything in the end will be about you. Your life may include anything, and need not be about you in this sense. There aren't any necessary ingredients to it, except perhaps *you* doing the taking in. It is your life only to the extent that you are the one doing the taking in. But this is just saying that the difference between your life and everyone else's is you. That you ate the tart is otherwise not shown by any ingredient or change in the tart, or by any choreographic inspection of your actions. The fact that you take in pictures and scenes is not judge-and-jury. What needs to be shown now is what may happen to you when you do that. What needs to be shown now is what happens.

4

What Happens

(§§151–199)

§151. What happens is something that happens to you. It is not that you need to fall off any horse. It happens to you in the quieter sense in which your thoughts, perceptions, feelings, or beliefs happen to you. You know that other people also have those, but you may easily tell yours from theirs. You wouldn't talk about art the way you do if what would happen would only happen to other people. Of course, when you talk about art, you may and often do talk about other people's beliefs. But talking about other people's beliefs is not talking about art. Nor will anything happen merely by talking about beliefs, your own or not, any more than talking about mumps will cause you to contract mumps. The sense that something happens with art is the sense that you are required by art, as some *you* is required by thoughts and beliefs and the rest. But just as no specific contents are required by thoughts or beliefs, so no specific you-occurrences are required by art. And in this art is unlike mumps. For instance, you are not required to contract any particular feelings, shed tears perhaps, or picture yourself with any particular images or thoughts. What happens is not content but that something happens to *you*.

§152. Here is an example of what talking about art is not. When the White Knight announces the "very, *very* beautiful" song, he adds that "everybody

that hears me sing it—either it brings the *tears* into their eyes . . . or else it doesn't." What is he talking about? Even if he were using the phrase 'beautiful song,' he would not really be talking about the beautiful song, and certainly not about art. This is because no "you" is required by what he is talking about. The Knight isn't talking about what happens, not even about what happens to him when he sings the beautiful song. Rather, he is talking about what *always* happens. What always happens is that a song will either bring tears to your eyes or not. This is similar to saying that any number will always be odd or even. The Knight could just as well be talking about the fish-poem. The song is for him just an instance of what is always the case, an example or a variable, like apples or oranges in an elementary arithmetic problem. What he calls the beautiful song could really be anything. The song doesn't matter to what he is talking about any more than a few apples matter to '7 + 5.' The Knight is not talking about the beautiful song.

§153. Would talking about the beautiful song be instead like asserting that something has happened, that is, has happened to you, that is, *really* happened to you? It need not be. That something has happened, even in the sense that it has happened to you, does not create any obligation on your part to report on the occurrence, no obligation to tell anyone that something has caused you to fall off our horse, and certainly no obligation to use the first person. Nor does it require that you put forth any explanations, or that you say that what has happened has happened because the song had certain features or properties that caused something to happen.

§154. That something has happened may nevertheless be shown in a wide variety of ways. To be sure, it may be shown in that you will talk about you and about what has happened to you and about the cause of what has happened to you. It may be also shown in how you talk about yourself and, of course, in how you talk about the song, even without mention of any happenings. You do not talk the way you do *because* of the song, but that you talk in certain recognizable ways is often how people know that the song matters to you. They may become annoyed at you, since it might often appear to them that you are talking about property owned by you. And this is because you talk about the song as you would talk about a thought you entertain, or as you would describe a dream you had, or as you would show pictures you had taken. But that something has happened need not be shown in how you

talk. You may not talk about it at all. Talking about it is as optional as having any particular feelings or behaving in a certain way.

§155. When talking about art, you do not use the first person more often or more emphatically; nor must you feel certain attending feelings, beautiful-song feelings perhaps, or shed song-specific tears. What happens does not cause you to talk in certain ways or feel certain feelings. That you acquire a belief or have a dream is also not always shown by grammar or feelings either. You don't have to say it and may not feel anything special. If you have come to believe that the earth is round, others will know it from your ideas about going to Knoxville, from assumptions you might develop about what Alice calls "the antipathies," and from things you do and, yes, things you say, think, and believe. That something has happened is like a conclusion you reach. It is a retrospective description, not the automatic registration of an occurrence. What happens may be shown by how other people, and perhaps also yourself, describe who you are. The fact of art is not necessarily that you talk differently or even that you talk at all but that, just as other people may have trouble determining what you are talking about, you feel no need or inclination to tell the beautiful song apart from you. It is in this sense that art is something that happens to you.

§156. When you talk about your thoughts, you don't feel the need to say 'This is me—and those, over-there, are my thoughts.' You do it wholesale, and you do it regardless of the contents. What counts as art of course is often the content of thoughts, whether you call it 'beauty' or 'Knoxville.' But it is also something you relate to as you relate to your thoughts. Art is sometimes not further away from you than your thoughts, beliefs, and impressions, not further away from you than your soul, your Knoxville pictures, or your feet. This is why when you plead innocence or personal ignorance you aren't really talking about art. You do plead innocence when you talk about what happens anyway, like the Knight talks about tears or no tears, or when you talk about what only happens to other people, like those who talk about art as something that only happens to others, or to objectionable people, perhaps to people long dead or very far away or very different from you.

§157. Could art be comparable instead to a series of implements you may have about yourself, though perhaps implements you care for in special ways,

or implements you collect for special motives? The White Knight appears to have all sorts of implements about. He seems to have motives for having them, however odd, and he certainly talks as if he would. He believes in the advantages of having plum-cake dishes, just in case you may find any plum-cake; and in having a beehive "in hopes some bees make a nest in it"; and in providing his horse with anklets "to guard against the bites of sharks." In his bag he also has candlesticks, carrots, fire irons, and many other things. You would surmise motives and prudential reasons, criteria, things added, and things detached. If art is collected about for such motives, then art is essentially a kind of equipment.

§158. And yet the Knight's motives are very vague. He only believes that "it's as well to be provided for *everything.*" This doesn't appear to exclude much of anything and contains no doctrine as to what to include. Anything might satisfy the general belief that you should always be provided for everything. Consequently, the Knight can never quite satisfy his general belief through any specific sum of implements, things you have about you for prudential reasons. Acquiring such anklets and carrots cannot be explained prudentially. The vague belief cannot yield any reason, let alone a prudential reason, and it does not contain any indication concerning what one should have about oneself. It does not translate into what you would call "equipment." The Knight's implements are not equipment. Each of them has happened to him instead, much like, and often as, thoughts do, perhaps as a series of afterthoughts. "I daresay you noticed, the last time you picked me up," he asks Alice, "that I was looking rather thoughtful?" The reason, he explains, is that "I was just inventing a new way of getting over a gate." The Knight's thoughts are as much his own invention as his shark anklets. What he has about him are in this sense the products of his own inventions. And who he is, what Alice takes in, includes anklets and thoughts, with no specific proviso as to distinctions between things mental and things out there. And what Alice takes in about the Knight is that contiguity between a certain animal, his thoughts, wishes, words, and many implements, rather than merely the contents of any justifications that that animal might have to offer. You would say that many different sorts of things are all around him *equally;* they are who he is, in the sense that *that* is what is taken in. A person for whom art is important is not a person equipped in any special way. Thus justifications of art as being good for certain purposes tend to be very vague, like giving reasons for something no

one really does, which will look prudential only in relation to something academic. Very often there will only be some general notion such as 'being provided for everything.' Think of art, then, not as a mere sum of specific items around some body, items having certain properties, causing them to have been amassed, and fulfilling specific functions determined by such properties. Think instead of aggregates of thoughts, feelings, beliefs, and implements, partaking with everything else relevant to the definition of a given person in the impossibility of being detached from that person. You may say that art is around you, but really any preposition or adverb would already concede too much. You really want to say that art is *so*-around you.

§159. But surely talking like this would leave you with no way to tell art from everything else so-around anyone, not to mention to tell the fish-quintet from the anklets or from a thought about the fish-quintet. And you certainly can tell art from not-art, and different bits of art from each other. That you can do so with no great difficulty is what makes you think of art as being anklets-and-carrots-like. However, you should not confuse the humdrum fact that the lists of what counts as art may change, may or may not include carrots and quintets, all stuff that comes to be and passes away, with the different, also humdrum, fact that anything from that list or not can be so-around you, and in many ways. You may own it, you may own a copy of it, you may have it, you may visit it, you may remember it, you may talk about it, you may hum it, and you may use it to describe other things, to predict the future, and so on. What counts as art at any given moment is always relative to items on someone's list, but art may only come to matter and become relevant because of the ways such items are so-around who you are. Such ways are what is taken in and what is relevant to the description of who someone is. No doctrine on the changeability of lists, no inventory of the actual contents of any bag, will ever explain that anything is around anyone in whichever way, just as no death certificate will quite explain your loss. Art is important to you not because certain things defined as art by virtue of displaying certain properties are around you in ways determined by their properties but, rather, because bits of stuff, defined as art by certain lists, are to you in many ways *like thoughts*. It is then about being to you, so-around you, rather than about being a kind of thing. People often imagine themselves acquiring a song, not unlike acquiring a possession out of a catalog. Indeed, you may go out and buy the song or an instance of it. And yet not everyone who does so will have

the song to them like a thought. Nothing follows from buying a song or from any behavior you may have. That thoughts are so-around you like thoughts is no behavior. And so, though acquiring a song can also be a part of what happens, acquiring a song cannot be what we mean by art, what we mean by what happens. In the only sense relevant to art, what you call "the song" is, rather, something developed, often over time, like you may develop a thought or a tooth, or like the Knight develops a new way of getting over a gate. This doesn't mean development has no causes; it only means it cannot be acquired as you buy a song. You may buy the song, but in doing so you are not buying whatever song-related thing happens to you. Thoughts and teeth, even false ones, you also don't acquire.

§160. When you talk about art, others may accuse you of not really talking; at best they may concede that you are doing something verbal, displaying verbal habits perhaps, but not that you are talking. Art-talk has the reputation of not being quite talk. The reputation is similar to that of talking about what is most so-around you. Art-talk has the reputation of being mad in this way, the mad way in which you go about telling your dreams and showing your pictures left and right, regardless of being a series of noisy, unimpeachable opinions, in this like all opinions you may have about yourself. But perhaps your verbal habits are good not only for imparting information, ordering one about, and making one repeat lessons. When you talk to yourself, you are not expressing any opinion. You often deal with the things you don't care to tell from who you are in verbal ways, and there is no reason those would be lesser verbal ways. Particular verbal ways may sometimes be an indication that you are dealing with things extraordinarily around you. It is also not that when you talk about what is so-around you are necessarily "very fond of pretending to be two people," because you are mad in any proliferating sense. Being two people almost never occurs to you and would indeed defeat the purpose, since it would require that you imagine your thoughts, beliefs, and art as being over-there rather than so-around you. But perhaps there is still a connection between certain verbal displays, those that often give other people the impression that there seems to be hardly enough of you left "to make *one* respectable person," and the fact that you matter-of-factly describe your commerce with the beautiful song as a verbal interaction. And it is not that you are mad. Or, if you are, other no less mad alternatives are often cultivated by those who resent your mad talk: they might claim that the song

speaks, remonstrates, and corrects you, and they might hold fantastic ideas about animation.

§161. Think of art-talk as being more like, as Alice says, "sending presents to one's own feet." By art-talking you often express a sense of something you can't quite tell yourself apart from, something as contiguous to you as your own feet. You may still officially say that the song is talking, but you know fully well that you do all the talking, and mostly do it to send presents to the song. Sending presents to art may express who you are and certainly is who certain people are like. When art is so-around you, you will often send it presents. Most, though not all, presents are of the verbal sort. This is what honoring art mainly amounts to—and is by no means a lesser thing about art. If art matters to you, art is something you honor as being so-around you, not something you describe as being over-there.

§162. People sometimes have the impression that they have become who they are, owing in part to what they call 'art.' When they look back, they see a change, and they attribute that change to the fish-quintet and its cousins, or to items they have learned to recognize as being in some art bag. Or, even if they don't have any elaborate theory about the causes of that change, they may still express gratefulness for a number of things, some, or even many, of which anklet-and-carrot, out of some art bag. They would say that without those various things they would not have become what they now are. Attributing a change in you to art is an attempt to explain a change in you. Expressing gratefulness, on the other hand, is more like saying thank-you. Both attitudes are common enough. They may be combined. And both share in the pervasive notion that, regardless of the effects of quintets, some people may have become different people, become people for whom art is now so-around. Could art have ever turned anyone into a different person? Could you have become a different person, perhaps even someone else?

§163. Think of the various different ways of describing the effects and roles of the fish-quintet in your life: you may say it made you a different person; you may say that it was as it were a natural consequence of your already having around you much quintet-stuff, perhaps quintet-minded people; you may say that it has made you aware of what you always were; you may say it has made you fall off your horse and see everything anew, made you become a

different person; or you may say it has quietly added to the furniture coming from multiple bags that you tend to own and haul. All these different ways attempt to understand and, to a certain extent, explain the fact that art is so-around you, the fact that perhaps on some morning you woke up with the quintet as around you as any thought you might have had, as about you as your very feet. Looking back, you might say the quintet, rather than having been placed around you, has developed *so*-around you.

§164. And you may believe that what happens is not worth describing, not in the sense that it is unimportant, let alone that there never was any change, but in the sense that describing it would be like emphasizing the wrong note. You may feel that describing it would give it the kind of specialness that would separate art from you in a way that thoughts and feet couldn't or shouldn't. The reluctance in talking about change may come in fact from an acute sense of contiguity with art. This would be no odder than your reticence to justify not the particular thoughts you might have but the fact that you have any thoughts at all. And you don't usually explain that you have feet either. Talking about the miracle of having feet, or the miracle of having thoughts, might strike you as a shrill way of capturing what for you has to remain humdrum in order to ring true. You may sometimes be tempted to say that you have art around you, as you have thoughts and feet. What, however, would be the point of saying such things? Often, if it weren't for other people, you probably wouldn't, as you generally don't feel that these are matters for talk. You don't announce that you have thoughts. You may send presents to your own feet, but you don't send presents to your present-sending inclinations. Sending presents to your own feet is not making propaganda for yourself.

§165. The Gryphon wants to hear some of Alice's adventures. " 'I could tell you my adventures—beginning from this morning,' said Alice a little timidly; 'but it's no use going back to yesterday, because I was a different person then.' " In this case, claiming that you have become a different person is a way of suggesting that no explanation of the change is worth pursuing. Adventures begin only after you are what you now are. And this is probably because Alice also believes that who she now is is in no way related to the "different person" she was yesterday. She was apples and now is oranges. There is no common yardstick, no common kind. It is not necessarily that she doesn't remember. It could be, however, that what she remembers about the previous

day is incongruous to her current sense of what is about her, her current sense of who she is. Or perhaps she is embarrassed by what she remembers, or she remembers it as one remembers a bad dream. It is in this sense that her yesterday-adventures might resemble someone else's adventures. However, it wouldn't make any sense to claim to have had someone else's adventures any more than someone else's thoughts or someone else's feet. Why would you want to do it?

§166. You may want to do it to suggest that you are not responsible for what you did or thought or had. This is akin to feeling shame and embarrassment, perhaps even regret, but also it may be just a way of claiming that the person you were, apples to your current oranges, is no longer in court and so cannot be put on trial. No adventures, no trial. And a statute of limitations would apply not to deeds or actions but to people as a whole. Limitations would apply to being someone. That the quintet could have once been over-there or even nowhere rather than so-around, as it now is, that it could have been some bad apple, is not a proud moment for you. Indeed, it might not even be a moment for *you* at all.

§167. But, of course, you would still have to *explain* that you were "a different person" until this morning. And this suggests that after all you might feel a little responsible for the misdeeds and misthoughts and mishaps of those you otherwise refuse to admit to have been who you are. Indeed, you cannot merely put away the different person like you put away childish things, like you put away a bagful of former bad ideas, of useless implements. Rather, saying that you were a different person is also admitting to some embarrassment as to who you were. Your former self may still hover about you. Its deeds and thoughts have this tendency to be as so-around you as anything, as so-around you as your feet.

§168. You may be embarrassed for having been "a different person," with many hovering, attending things about that you now see were dubious; but, of course, you may also be embarrassed by who you are now, embarrassed by the company you currently keep. In both cases you often also want to say that there is nothing you could have done, and so ultimately to say that who you now are is not to be seen either a way of making up, or a punishment, for who you once were. And just as you are not particularly grateful for having

been a different person, so you do not feel any inclination to atone for that person. Why atone for someone else's shortcomings? Why be embarrassed for someone else? In claiming to have been a different person, it is not your embarrassment that you advertise, not even your vicarious embarrassment. You announce the possibility of describing yourself, what is so-around you, as something that happened to someone else, the possibility of describing what people generally consider to be around them the most, their thoughts, words, and actions, as choreographical products. You announce the fact that until this morning nothing had really happened to you and so that there are no outstanding adventures there for you to talk about. What the different person did, thought, or had would be, at best, undefined, extraneous, goings-on, antics. Of course, beyond the stretched grammar of these pronouncements, one may wonder if such contortions are things you can do to who you are, and this regardless of what you may or may not have so-around you. Perhaps if you are, you also *were* before this morning, and so you were only calling yourself someone else all along. There is a tendency to call bad apples oranges.

§169. Do you remember what happened earlier? Alice remembered already "feeling a little different" that morning. She then wondered whether she had "changed in the night." Is what happens like having changed in the night? And is the fact of art like developing a cold, like something that only causes you to feel a little different, or instead like something more serious, say, like developing cancer? For Alice, "feeling a little different" is already a serious thing. It matters little to her that this is something you perhaps only *feel,* and even less that you *little* feel it. When you feel a little different, Alice says, you're not the same, and that is that. You may just feel a little different, and you may not quite feel like someone else, but you know you could only have been changed *for* someone else. Who you were yesterday is now far less even than over-there.

§170. When you say that art may change you into someone or something else, you do not mean that it will change you into a fish or into anything unfamiliar. It is relevant that even when you claim to have become someone else, you also admit to already having had some intimation as to who you might become. You often claim to have become like people you used to admire or love, even to have become an improved version of how you were. You believe art to be a good thing, namely, because you believe what happens to be an

improvement. Who you now are would still otherwise very much look like you and would know all the things you used to know, though of course would also know a few things you didn't, and do things you didn't, and have thoughts you didn't. You may not know precisely who in the world you now are, but since you only feel a little different, who you are must be someone you already knew, or at least a little like who you used to be.

§171. Couldn't you determine who you are once and for all, experimentally perhaps, and get it over with? Surely that you change into someone familiar appears to suggest that Alice must be, as of this morning, one of "all the children she knew that were of the same age as herself." This has the advantage of still being compatible with the possibility of her having merely become a different version of herself. And even if she may not be herself, or any version thereof, she would certainly be someone very much around herself, perhaps the same age, with similar looks. She couldn't, however, be Ada, since Ada's hair, unlike her own, had ringlets. Could she be Mabel? It doesn't look like it, since, she says, "I know all sorts of things and she, oh, she knows such a very little! Besides, *she's* she, and *I'm* I."

§172. Here is a possible test: "I'll try if I know all the things I used to know." Since Alice no longer knows Multiplication and Geography, and since when she tried to repeat "How doth the little–" the words "did not come as they used to," it looks that, whoever Alice is, it no longer knows what Alice used to know. This result appears at first to be incompatible with the belief that she has merely become a version of Alice since, of course, she knows less than what she used to know. However, you can forget things and still remain who you are. And that you can remember who you were or what you knew does not necessarily show that you haven't been changed for someone else. Other people routinely remember what you have forgotten, and you may ask them for help. Not knowing Multiplication is not merely having forgotten multiplication. You also know what you no longer know. And so it is not a matter of remembering, however much you may be determined, not a matter of moving into a state of mind more propitious to remembering. By not knowing Multiplication, you mean you can't do multiplication. And claiming that you no longer can is like claiming that you have lost something, not like claiming that you forgot anything. If knowing who you now are would be a matter of finding a remedy for having forgotten who you are, and since everything

would depend on your remembering it, you would always be judge-and-jury about it. And so *you* would never be able to prove that you are yourself by remembering who you are any more than you would never be able to prove that you know Multiplication by *remembering* that you know it.

§173. All tests to determine who you are invariably end in disappointment, and this is perhaps why they are rare. Instead, the question is why would you have to determine who you are? You know that you are you and that she is she. To prove it seems to require that you appeal to some kind of memory you have. In relation to your memories, however, you will always be judge-and-jury and so they prove nothing. The failure of such tests may encourage you to embrace the more momentous possibilities: you may conclude that you have been changed for someone else, without a trace. But as you wish to account for humdrum things like a hairstyle that remains constant, you will almost always conclude that you have been changed for someone just like yourself. If Mabel, since she doesn't know any Geography, is just like you, then you must have been changed for Mabel. This is, of course, Alice's conclusion. However, there is something funny about it. If Alice doesn't remember being changed for Mabel, 'Mabel' may be just the name she calls herself, shorthand for something like herself-minus-the-ability-to-do-Multiplication, as if you would change the name you call yourself every time you lost a pair of glasses. And if Alice claims she was changed for Mabel because she remembers it, she won't ever be sure she hasn't. You may attribute this difficulty to what happens, and, if it happens with what you call art, to the depth of art, to some of its properties, but it is really caused by your insisting on a test when no proof was required. You can't experiment with the fact that you are who you are—there simply are no tests for what is so-around you.

§174. "So you think you're changed, do you?" the Caterpillar asks Alice, implying physiological acquaintance with the process. However, when you say that art causes people to become different people, and mean it in the sense of "I must have been changed for Mabel," you do not mean physiology, unlike the Caterpillar, and you are not committing yourself to explaining change in physiological terms or implying that someone's feet became Mabel-feet through physiological means. You will imply more obscure psychological currency instead. The Mabel theory of art generally announces psychology. You may, for instance, claim that due to art you now remember, or have the impression

of, you may have been a different person and are perhaps a little embarrassed of ever having been that different. If this is the case, art should be a good thing, a thing that causes you to become a better person, which causes your philistine former self to have been changed for art-infused Mabel.

§175. There is no need to suppose that the fact that what happens happens to you entails that you become someone else, by means physiological or other, or that you have been changed for someone else, or even that you remember whatever has happened. What happens may not be for you to remember at all. The conclusion that she has been changed for Mabel is drawn from what Alice calls "feeling a little different." Alice concludes that if you feel a little different, you are not the same, and if you are not the same, you have been changed for someone else. But the fact that you feel a little different does not quite amount to your having been changed for someone else. Having brushed your teeth makes you feel a little different, though a new person only by courtesy, and at best. You routinely feel a little different, or even a lot different, and still do not entertain any doubts as to whether you are still yourself let alone the notion that you have been changed for someone else. The Mabel theory of art is exaggerated, as when you say that brushing your teeth has made a new man out of you. But its exaggeration expresses something. And the joy of having brushed your teeth is not without relation to the joy you may feel at the quintet. For one, they both happen to you, and in both cases you are not describing anything remote. The Mabel theory of art appears to point to something important, certainly to an important aspect of what happens. The theory claims that what happens happens to you, and that it happens *very much* to you.

§176. What happens to you and what you try to express as "feeling a little different" is really not any feeling, that is, an occurrence or an impression that you need or may remember at all. You describe what happens not by pointing to any feelings, or trying to find the words to capture, say, a very particular subspecies of joy, or by identifying a feeling from a feeling catalog, but instead by coming up with a changed list of what is so-around you, or by realizing that it does not make any sense anymore to just say that the quintet is over-there. You change your mind, not your body or yourself. And you may even add that you now understand the quintet, since very often to claim that one understands something is to claim that that thing has become one

with one's thoughts. And all of the aforementioned sometimes may be paraphrased by "feeling a little different" or perhaps by 'feeling a little different about the quintet.' And although there may be feelings to it, there need not be any specific feelings involved any more than there are any specific contents required by your quintet-thoughts and quintet-beliefs. When you say that you feel different about the quintet, the point does not seem to be that you feel quintet-specific joy, and you don't expect to be prompted to identify any actual or putative feeling. This is unlike having an idea about a color and trying to describe it in a shop, and being prompted to identify the color from a catalog. You say you feel a little different about the quintet and the emphasis does not appear to fall on any feelings you might have, and which you may actually have, but, rather, on something quintet-related that has happened. Something quintet-related has happened *to you*. This is a description of art. Something related to something out of the art-bag has happened to you. To that extent, what happened to you happened because of the quintet.

§177. A description of art requires a description of what happens, and a description of what happens intimates a notion of who you are, and one that includes what is so-around you in a definition of 'who you are.' To do that, however, it is of little use to go around asking 'Who are you?' Such questions are not "encouraging opening for conversation." They are personal questions, cousin to personal remarks. Personal questions are hard to answer, though not always for personal reasons. That you are you does not necessarily mean that you have any ideas about how to answer a 'Who are you?' question. And yet the difficulties with personal questions may show that there may be advantages to pursuing them independently from piecemeal-collecting answers to 'Who are you?' questions.

§178. When you admit to feeling a little different in response to a personal question, you mean that something has happened to you. But really what has happened was not so much and not necessarily that you have changed sizes or have been hijacked but that many of your beliefs relative to yourself and relative to many other things have changed. Certainly the list, should you put yourself through the trouble of making one, of what is definitely not over-there has changed. That Alice now feels a little different means, for instance,

that she has come to believe that you can drown in your own tears, that what looks like a hippopotamus may be a mouse, that she can control her size by eating or drinking various things, and, not least, that people can go out "altogether, like a candle."

§179. Size and bodies and where you are of course matter to how you answer 'Who are you?' questions. Were you to deal with "an enormous puppy," as opposed to the more familiar varieties, your expectations about what to do and what your commerce with the puppy might announce would likely change, as would perhaps your notion of human finitude. Like Alice, you might fear it could eat you up and so be "terribly frightened all the time at the thought that it might be hungry." A change in size might have caused a change in beliefs. But what happened to *you* was a change in beliefs, not a change in size. When Alice eats cake, she changes beliefs. In most cases, when you change beliefs, you remain the same size. To be sure, Alice remarks, "this is what generally happens when one eats cake." What happens need not entail any exception to the laws of nature.

§180. "Explain yourself!" the Caterpillar commands. "I ca'n't explain *myself*, I'm afraid, Sir . . . because I'm not myself, you see," Alice replies to the Caterpillar. Alice's personal difficulties are independent from any theory she or anyone might have about the idleness of proof and explanation in such contexts, even when you don't feel differently, and even if you don't particularly believe that proofs or explanations are required. There are difficulties common to explaining yourself and to answering 'Who are you?' questions. You often deflect 'Who are you?' questions into 'What are you?' answers. This suggests that you assume you are asked 'Who are you?' questions for 'What are you?' reasons, much like the person asking the questions would make the 'what' sound like a 'who,' perhaps by pronouncing it in a certain way. Alice's reaction to the Caterpillar's command, on the other hand, emphasizes 'myself' in odd ways. Her understanding is not so much that, due perhaps to changes in size, there might be nothing left for her to explain, but that you wouldn't know how to go about explaining yourself any more than you would know how to go about drinking a fish. Puzzlement over explaining yourself may sometimes be quasitechnical. You may not know how that is done. Demanding a personal explanation is, in this sense, not demanding personal justifications for one's

actions, which at any rate are never personal, and so perhaps because of that are much more common and useful. That is not how Alice understands the Caterpillar's command. She understands it as demanding that you explain *that* you are yourself. And you, like Alice, may feel there is not much for you to *explain* there.

§181. The Caterpillar's demand for explanation starts from "Who are *you?*" Alice talks about *what* she assumes 'you' refers to. 'You' is the Caterpillar name for what she calls herself. But if she can only talk about what she calls herself, her explanations will always tend to assume what is to be explained, namely, what both the Caterpillar's 'you' and her own 'myself' refer to. The Caterpillar notices the difficulty: "You! . . . Who are *you?*" Explanation is, in this way, swiftly brought to an end. It didn't work. The Gryphon later suggests another procedure: "The adventures first." "Explanations", he adds, "take such a dreadful time." You who have been changed for Mabel will instead "tell adventures" and will begin from when you first felt "a little different." By telling adventures, you are calling a truce regarding explanations in the sense that your telling no longer purports to answer any of the unpromising "Who are you?" and "What are you?" questions. To be sure, your adventures are not quite as so-around you as the explanation you hopefully had imagined would satisfy the "Who are you?" question. And, still, the adventures are very much about what happened to you. Your adventures are your own, but at the same time they are not as straight an answer to 'Who are you?' as pomology is to 'What is an apple?' They are not 'you-ology,' nor will they ever yield any explanation for the fact that you are yourself. Instead, telling adventures is, for you, a verbal way of dealing with things about, of dealing with things so-around you. It often may be a present sent to your own feet, an expression of honor and gratitude. It may express relief at not having to answer any more 'Who are you?' questions, at not having to provide any further explanations. And telling adventures seems to require, in all cases, that you approach other creatures—gryphons, mock-turtles, caterpillars, or sisters. Hitherto used to giving herself "very good advice" and generally "fond of pretending to be two people," Alice ". . . was a little nervous about it, just at first . . . but she gained courage as she went on." You may become used to telling adventures and may become good at it. Perhaps you yourself often were told adventures when you were a child. When you tell your own adventures, your audiences will know that what happened to you is not separate from that you are yourself. They will know who you are.

§182. When you are told adventures, you understand what is so-around someone. To that extent you also understand something about what you are told. But you are never explained what you understand; understanding is never brought home to you by dint of answering who-questions, or even what-questions. Adventures are descriptions of changes in what is so-around some creature, perhaps, though not always, the creature doing the telling. As you understand what is being told to you, you will realize that some stuff was over-there, and then very much around the teller, and then again over-there, and then perhaps some new stuff got closer. Your description of the creature will be a description of changes in what stuff counts as being so-around, not of apples unaffected by accidents. The apple is, in this case, what is so-around the apple. Who that person is is a series of changes in what goes so-around her. Of course, if you insist on knowing *what* she is, which sometimes may be quite enough, creature-pomology will suffice. "I—I'm a little girl," Alice tells the Pigeon, though "rather doubtfully, as she remembered the number of changes she had gone through, that day."

§183. People who ask you 'Who are you?' may mean it as 'What are you?' or at any rate may mean the question as a demand for explanations. You know that the 'what' doesn't do justice to the 'who' in the question, but you also know that who you are is not anything to be explained, let alone by you. If answering what you are always sounds like apples to oranges or at any rate like pomology to apples, explaining who you are rather feels like drinking a fish. And so by telling adventures you call a truce regarding both explanations and pomology. Telling adventures thus expresses yet another deflection while perhaps remaining the only possible way of doing justice to what in the original question was confused for both definition and explanation—that who you are is something that is about *you,* however quietly. It does not say what you are and does not explain who you are. It goes about personal questions by listing you-related changes. It deflects 'Who are you?' to 'Where are you?' Adventures, in fact, tell where you are. They do it by describing you contiguously with the various stuffs so-around you, and also by describing changes in what is so-around you. And so perhaps adventures capture both what you obscurely had described as "feeling a little different" and what you had mistakenly taken for having become someone else. Telling adventures is telling what happened to you, the long and only viable shortcut to 'Who are you?' The question all adventures answer is what Alice calls "the next question": "Who in the world am I?"

§184. "Ah," Alice concludes, "*that's* the great puzzle!" However, is it correct to call it a puzzle? 'Who in the world are you?' may suggest impatience, but it also simply states that who you are is who you are in the world, that is, where you are. It is not like you feel you have to guess at the solution. The world is what you call what is so-around you; you only have to find a description. If art is so-around you, art is where you are, and to that extent who you are. Art is not a separate world, not a special world that may be described separately from you, like a set of thoughts not entertained by anyone, or perhaps a set of disembodied feet. Art is always stuff about, and thus often very much a part of who you are in the world. Stuff about is so-around you like thoughts. This simile only expresses the fact that you know it wouldn't make any sense for you to describe it as being over-there. If the fish-quintet is about, then it is not wallpaper to your world, nor an image or a description of who you are, let alone wallpaper to something stuff-less you might otherwise imagine to be who you are.

§185. Your adventures will sometimes tell how the fish-quintet developed into something so-around you. And a few people will tell where they are by telling quintet-adventures. But telling where you are does not in any way require quintets or what you call art. People will often ask you where you are, and you will be a little afraid of being so bluntly asked, but only sporadically will you describe yourself amidst quintets or poems. Art is the contents of a bag, not a necessary ingredient to telling adventures. The importance of art is to be understood relative to the importance of adventure telling and may perhaps only be gauged when you realize that comparatively few people pay it any importance at all, and perhaps even fewer people have it so-around them rather than over-there. The always possible situation where someone else will puzzle over the fact that other people, perhaps in the past, could have had art about them, as perhaps you may puzzle over cannibalism, will never diminish the importance of the fact that at a certain point in time, for certain people, the fish-quintet was like a thought, or like your feet, rather than like a thing. And the fact that they had sent it all kinds of presents was also part of telling where they were.

§186. Can you lose art? Can you lose art like you lose stuff? Just as you may develop a thought, so you may lose a thought: all kinds of stuff may be lost. When you lose something so-around you, what is lost is the possibility of not

seeing stuff as over-there rather than so-around. This is a change of size, of sorts. You lose *beliefs* about stuff. Think again of Alice and the Fawn. Here you have Alice "with her arms clasped lovingly round the soft neck of the Fawn." There you have her "almost ready to cry with vexation at having lost her dear fellow-traveler so suddenly." By losing a fellow-traveler, you change places, that is, you change the sense of where you are. When art is fellow-traveler to you, you often also travel about with arms clasped lovingly round its soft neck. Your clasping suggests the intensity of the love but also perhaps intimations of a possible loss. And still you may wonder if one may feel *vexed* at having lost the quintet. You may feel vexed at having lost a person, or your glasses (it need not be the same kind of vexation, and it need not entail that such losses are on a par). Is it the case that you lose the quintet like you may lose a fawn? Is losing art like losing a person? Is the disappearance of a whole art form like genocide? And, consider this important related question: Do you always mourn the passing away of stuff about you in the same way?

§187. You lose the quintet like you lose a thought, or an idea, not like you lose a person. You lose it like something you develop, not like something you acquire. The quintet is like that. And this suggests that at least as far as its being about you, the quintet is not and never was a thing. Of course, you can identify the quintet as well as any candlestick, but that you do so will be in this respect as futile as *calling* the quintet, similar in all to shouting 'Quintet ahoy!' On the other hand, you rarely miss stuff lost in the way of thoughts, words, or ideas. Losing the quintet is not like the death of Mutton. You may mourn Mutton, even if it wasn't real Mutton. Rarely will you miss or mourn a lost thought or a lost quintet, even if either was completely real or not unreal in the Mutton sense. And still you may lose the quintet in countless ways. You may leave it behind much like you would leave behind a penultimate idea. A time may come when you no longer see the point of sending it presents. Perhaps one morning you might have woken up "feeling a little different," embarrassed about your former clasping embraces that you now see as antics, now as remote as someone else's antics. And then you might have no reluctance in describing it as totally separate from you, like you wouldn't mistake someone else's feet for your own feet. You might even find it funny that you could have made that mistake. Or you may forget everything about it, without ever remembering ever feeling any different about it.

§188. Alice's interactions with the Fawn are, however, in another respect, quite similar to your interactions with the quintet. And insofar as she has the Fawn about her, she feels no particular need to tell her own adventures or send presents to anything so-around her, except for the loving clasping of the Fawn's neck. However, as soon as the Fawn darts away, her words come back and the present-sending, the talking-about, may begin. All these interactions are supposed to take place in some wood "where things have no names" or, better, where you can't remember any names. But they really are less about remembering anything than about using, and having, words for something, about talking-about. The words, and the vexation, only come up when Alice is out of the woods. This explains, perhaps, the widespread, and partly true, intuition that when you talk too much about anything so-around you, that thing must have already darted away, or at any rate that you might be distinctly aware of that possibility and of that danger. You imagine that wanting to preserve the quintet is independent from any words you may offer it, either deliberately as an honor or nondeliberately as a symptom. You may believe that preserving the quintet is a matter of clasping lovingly to its neck.

§189. Telling adventures is less the consequence of your remembering those adventures than the consequence of being out of the woods and out of fawn, that is, of talking-about. Telling adventures is not the embracing of fawns by other means. There is no other known means for such embracings. Nor is it a fawn-preserve for the benefit of future generations. Future generations almost never indulge in your intended venison; they will never cultivate the quintet in your own clasping ways. Your telling is instead the function of your "feeling a little different." This is why the fawn-clasping will always be somewhat of an antic relative to your telling. Yours are not the adventures of a different person, but they are your own adventures as a differently sized puppy, as it were. Perhaps this is why people who art-talk insist on keeping the talk separate from previous moments of wordless appreciation. When you talk, you no longer are where you say you are, and the stuff about you has shifted. When you say that the Fawn has darted away, you really mean that certain thoughts and certain feelings have deserted you. Your sorrows may have multiplied, but this is only because the fate of your adventures is no longer up to you, up to your thoughts and feelings. Telling adventures is no judge-and-jury, purely perceptual, business. Instead, your adventures are ways of responding to

someone else asking you where you are. And you respond by saying that something happened.

§190. The sense that something happened to you is very important to art-talk. It is not, however, that art-talk is about remembering or describing what happened to you. Indeed, just as in your clasping days you didn't remember anything, so now you know that the quintet was not in any way forgotten or misplaced, like you might forget or misplace your glasses. Nor does art-talk respond to 'Where are you?' by *explaining* where you are. Rather, art-talk is an instance of where you are, and so of who you are. You are not who you are because you remember the quintet, or because you can describe the intensity of your quintet-clasping, though you may well say you do and, indeed, may. You are who you are in the sense that anyone will not fail to conclude that the quintet is not like a possible belief for you to entertain, a course of action, an antic, or a theory. They will think of you as contiguous with the quintet, as people see you as contiguous with your opinions and your feet. They will not say 'here he comes, with his feet attached.' You come, feet and all. Now some people will be quintet and all, art and all. This is who they are. The word 'attached' does not occur in such descriptions. And that they quintet-talk will be instance and evidence of that, just as talk can be instance and evidence of your thoughts and beliefs. But it would be conceivable to conclude that someone is quintet-related without their ever having quintet-talked or even talked at all. Most people do not talk about what is most around them, and still you may have no doubts as to who they are. There are many ways for you to realize who a person is, many hints, many cues and clues, and many possible indications and instances.

§191. So here you come, art, feet, beliefs, and all. Why send it presents, though? Someone else might say that there is something pointless in art-talk if you are that kind of person. At best you could explain art-talk if you aren't. What is pointless, they might add, is the very notion of telling who you are. As Tweedledee has suggested, you won't make yourself any bit more real by telling who you are. Couldn't telling also be counterproductive, like protesting too much? So much effort to talk about art and to intimate that art is so-around you might end up raising the suspicion that what you talk about has, after all, darted away and is over-there rather than much about. You might

want to argue back that it is psychological, something you come up with in lieu of the loving clasps, perhaps a confused belief in the possibility of clasping by other means. Perhaps you would even call it an emotion corresponding roughly to being out of fawn. But if you see it as the consequence of having confused beliefs about art, then you also surely already know better. If you know your beliefs are confused, then you also already know you are elsewhere. So you can't really describe your present-sending as an emotion you might have, as that would have to be someone else's emotion.

§192. You might imagine instead that at a certain point in time groups of people might have been encouraged to talk about who they believe they are, encouraged to describe the minutest details of everything they believed mattered very much to them. This you could call a culture. Such a culture might look like a good idea, all art and truth and truthful art-talk. Would it also require that people send presents to their own feet? After all, your feet are also truly where you are, as truly as quintets and poems and the rest. Well, truth telling in this sense is only to be enforced about certain things. Talking about the fact that your feet are your own would not really be necessary—not so talking about the fact that the fish-quintet is so-around you. What, then, makes the quintet so special to who you are? For one, whereas most people have their own feet about, not all people have the quintet about. So you can't presume too much that anyone has the quintet about, just as you can't presume too much that everyone is also a Swede. You might ask why it is so useful to publicly declare the truth on those rarer matters. You might imagine being generally encouraged to speak the truth about those things that may only be so-around relatively few people. 'Generally encouraged' intimates the culture. Such a culture would encourage you to be like everybody else by talking about who you are and about everything that is so-around you. Everything so-around you, by being talked about, would become the antic of a larger number of people. What appears to be discouraged in the process is any emphasis on the notion that anything might have ever happened to you, that you might be anywhere at all, and that you might have beliefs about where you are, and adventures to tell. Thus the notion of general encouragement, like most culture-talk, tends to discourage the very fact of art. That you tell adventures, that you tell what happens, which may or may not be culturally encouraged by various kinds of talk, cannot be the *consequence* of any culture.

§193. The difficulty is that art looks over-there when you talk *about* it, but *that* you talk about it suggests it isn't over-there. When you emphasize the latter, the fact of you sending it presents takes precedence over the presents sent; when you concentrate on the former, however, you only describe the actual presents. And so art-talk is two things at once: what you talk about and *that* you talk about it. Merely describing what is said is like treating presents as chosen, bought, and wrapped in some stuff-less, unpopulated world, the world of a culture. And, of course, what you are leaving out is that they are presents. So the correct thing for you to do in relation to art-talk is not to concentrate on things said but rather on *that* things are said. The connection is one between art being so-around you and things being said, not one between art being so-around you and *certain* things being said. This is why, ultimately, it matters so little that you may believe that the quintet will remonstrate. Whatever the nature of such remonstrations, its answers will always trickle through your head "like water through a sieve."

§194. Sending presents to your own feet is something much like the beautiful song. Or perhaps the beautiful song describes a loving clasp of sorts, minus the pretense of there being any necessary fawn about you. In the beautiful song the Knight addresses an "aged aged man" and always asks him the same questions. His answers don't matter, and, indeed, the Knight has little time for any answers. What matters to the Knight is that he asks questions. And the succession of the Knight's questions does not yield progress, or any incremental knowledge of the aged aged man's goings-on, any more than asking that the quintet questions will ever yield any amount of quintet-knowledge. Because of this, art-talk will always seem ludicrous when described by anyone who has never had any quintet so-around. To most, there is something laughable about *that* you art-talk, not to mention that you send presents to your own feet.

§195. Wouldn't it be simpler to imagine instead that the quintet is something out-there and that you talk about things out-there, that some of them don't remonstrate and that you may learn how to correct the things you say about unremonstrating things, and that, as you go along, you will know more and more about the quintet? Talking about quintets would not even be a special case. *That* you talk about art wouldn't be any more remarkable than that you breathe. Both would be seen as a means to something else. And art would

only be about what you talk *about*. You talk about all sorts of things and nothing special needs to happen so that you talk. This is what most people believe art-talk and art are like—the simple version at least.

§196. And yet the simple version cannot explain many things about art-talk. It cannot explain the little use you have for the notion of knowing more and more about the quintet, and that you do not resent its hopeless unremonstrancy. It cannot explain your otherwise unreasonable emphasis on judge-and-juriness and clasping stories whenever you are announced to be wrong. It cannot explain that *that* you talk is at least as important to you as what you actually say. It cannot explain that you often correct what you say by appealing not to other people's objections but to what you perceive is the hard-to-describe sense that your words were not quite right, which so often gives it all the impression of tuning an instrument without a tuning fork. It cannot explain that very often you also want to capture the sense that something has happened to you relative to the quintet, for example, that your beliefs have changed, and the sense that the quintet changes according to your beliefs. It cannot explain that the quintet matters to you for reasons not exclusively psychological and not merely cultural and definitely not because you have eaten a certain piece of cake. It cannot, in sum, explain your dissatisfaction with the notion that the quintet is out-there rather than so-around you.

§197. Two people art-talk not so much as they would gradually construct a better description of what the fish-quintet is through cooperation. What would be the point of such an exercise? And people mostly *disagree* about art anyway, while being unable to indicate what would count as agreement. But surely saying the same thing would count as agreement. However, even an abject concession does not necessarily count as an agreement. Art-talking creatures agree more like people making noises in the same frequency, not like people saying similar things. Or, rather, what we call agreement is, variously, that certain things are said, that anything at all is said, and that nothing is said. And yet the presumption of an agreement leads two people to conclude that they are similar people, or people to whom similar things have happened, and act perhaps on that conclusion. But what they share is not necessarily, and not frequently, the contents of what either of them has said but often the fact that they both have said it or that neither has. Looking at art-talk as a debate thus seems to be misleading. Art-talk is *that* a number of

people say things or don't, not what they say. And, like the beautiful song, art-talk proceeds by repetition. If you see it as a debate, you can only see it as a faulty, mad debate.

§198. You need not see art-talk as a debate any more than you see two people singing in a choir—and perhaps keeping silence for long stretches of time—as a debate. Instead, you should pay attention to the fact that there is talk at all. When you learn how to talk about the quintet, what you learn is a version of singing. And you may learn when to sing at all. What you call art-talk is, therefore, often not what you would call talk; and still it is about what happens, about that something has happened to you, and about where you are in the world. In this, art-talk is again similar to the beautiful song. In the beautiful song the White Knight describes a series of adventures. He does it not because the song states what happened to him but because it is contiguous with who he is and exemplifies who he is. The Knight takes in the "aged aged man" and concludes that "now, if e'er by chance" he does certain things or certain things happen to him, he weeps, "for it reminds me so / Of that old man I used to know." Weeping for the "aged aged man" is just like hoping for the crow to come or sending presents to your own feet. You take in something so-around you. You tell where you are. A choir of people taking in and honoring what is so-around them, telling adventures, and describing what happened to them—that's art-talk. That you are doing the same thing or nothing at all rarely is the consequence of agreeing on any propositions any more than it is the consequence of voting on what the case is.

§199. "What a long sleep you've had!" Alice's sister tells her. And then Alice describes "as well as she could remember them, all these strange Adventures of hers." And then the sister, "thinking of little Alice and all her wonderful Adventures," begins "dreaming after a fashion." The sister's dream is both repetition and a continuation of Alice's dream; it is Alice's dream, and then a dream about Alice's dream, about how Alice "would gather about her other little children, and make *their* eyes bright and eager with many a strange tale." It is not that the sister understood Alice's dream any more than you are required to understand that someone else is also singing, or someone else's silence. But the present-sending could continue. The sister's dream suggests the possibility of catching, mumps-like, a dream. This is how what happened to Alice happened to Alice's sister, "after a fashion." Alice's adventures became

in her dream thoughts to other people, became so-around other people. And those other people might occasionally develop the hope that others will acquire their own thoughts. This is the hope that what happens to you will happen to others, the hope of poems, quintets, and the rest. It is the hope of art and what art is like.

Analytical Table of Contents

1. Ideas (§§1–55)

People sometimes believe poetry is a foreign language (§1), but the language cannot be translated and has no native speakers (§2); there is no language of either poetry or of art (§3). There are no special words for poetry, no special sounds for music, and no special colors for painting. 'Foreign' means unfamiliar (§4), which is to say means *that* you don't see something (§5). The word can be used both as a term of diffidence and as a compliment (§6), and it cannot be understood absolutely (§7). Some people call foreign things wonderful (§8) and others call wonderful things foreign (§9). Alice's doctrine is that poems are pretty things that fill your head with fuzzy ideas (§10). Fuzzy ideas need not be false—they are just hard to describe (§11) and often not enjoyable (§12). Alice tends to be disappointed over poems, and she calls them pretty (§13); 'pretty' may also mean unfamiliar (§14). 'Pretty' and 'wonderful' are often used by people not very familiar with poems (§15). Understanding a poem is like understanding a cat; neither ever says anything back (§16), and thus you can't hold a conversation with them (§17). All art is like this, but not only art is like this: nature, the past, and numbers are also like this (§18). However, doctrines about poems and about cats are often about how to hold conversations with them, and they are believed to talk back only in languages you know (§19). This doesn't mean they are mad (§20); madness in art consists instead in imagining a hidden connection

between causes, effects, and yourself (§21), and this is also related to the idea of a conversation (§22). Regarding expecting help from poems, help with poems (§23) is contrasted with help from poems—the idea that each poem has an instruction manual attached (§24), and hidden, which, however, always corresponds to the ideas people have about the poem (§25). Regarding teaching art and looking for help with art and from art (§26), you never overhear art (§27) and never *surprise* art (§28), though you may be surprised and annoyed by people doing unusual things at art as you are surprised by unfamiliar kinds of life (§29). 'Unfamiliar' does not mean mad; what is mad is assuming that what is unfamiliar never matters (§30). The importance of being able to describe how you acquire and lose familiarity is connected to what is entailed by encouraging familiarity with art (§31). Claiming that something is nothing but something else (§32) usually means that you don't care about it (§33), for example, ceasing to care about something (§34), the use of 'pretty' and 'curious,' and seeing it as nothing but a dream (§35). Regarding justifying care and giving reasons, there are possible reasons for caring about poems (§36) and similarities between expecting help from poems, animal entrails, and archaeological remains (§37). Regarding poems used as evidence (§38) and evidence and reciprocation (§39), there is no reciprocation in matters of art and so no point in imagining a contractual understanding of art (§40). This does not exclude the possibility of a poem being helpful evidence (§41), even immediate evidence; if you are familiar with poems, you will tend to see them as offering immediate evidence (§42). Things in poems are like anything else (§43), despite the fact that familiarity with art often causes you to widely use scare quotes when, for example, you talk about things in poems. This makes no sense (§44). Rather, talking about what is "in the poem" is like talking about the peculiarities of a slightly unfamiliar place (§45); poems are not separate worlds, and this is why your opinions about poems are contiguous with your opinions about everything else (§46). Regarding losing contiguity and nonsense (§47), you blame words (§48) and suggest mysterious explanations (§49). Using words of poems to describe other things (§50) is not to see the world as if it were art, since the words of a poem are just like every other (§51). Seeing yourself as described by a poem is like seeing a poem as a law of nature (§§52–53), even if you don't understand anything about the laws of nature (§54). You often act on fuzzy ideas, and so it is no surprise that you often act on the fuzzy ideas attributed to poems and art (§55).

2. Furniture (§§56–103)

When you talk about people in poems, you don't mean honorary people (§56), nor do you *pretend* they are people (§57). A problem with pretending is that you can't pretend together (§58). Pretending is a mental remedy and so no remedy; besides, there are no honorary people (§59). People in poems are part of the furniture you find about the place (§60), and no one confuses people in poems with people out of poems. Asking what furniture in art is insinuates that there are various kinds of furni-

ture, real and honorary (§61). You know how to deal with furniture in poems and quintets because you already know how to deal with many other things, and deal with poems and quintets in ways similar to many other things (§62). You don't define what things *are*, for example, through pretense (§63); you ask the locals, though the locals never tell you what things are. Asking what poems and quintets are will only indicate that you are not a local (§64). You change your mind about poems and quintets like you change your mind about someone, not because you change your mind about what anything is (§65). You introduce poems like you introduce people, and you don't introduce someone as a character, just as you don't introduce anything as false, blue, or even (§66). Action-capable furniture usually has thoughts and attitudes and moves about. There is no need to be reminded that some furniture does not exist or to use scare quotes when talking about what it does (§67). There is no need for a separate science to explain what nonexistent things can't do (§68), and no need to inform nonexistent things that they are so (§69). How you describe bits of furniture often indicates what you know about them and their past (§70). Describing something is not pretending anything about it (§71); it is not that cats or poems agree with you but that you talk about cats and poems, and people in poems and out (§72), about action-capable furniture, in a very limited number of ways. Talking about art is talking about action-capable furniture, and the furniture comes with the generic talk (§73). This does not mean that you and your talk are always the master (§74), or that the furniture talks back by mere ventriloquism. Art, never an arrangement or an arrangement with yourself, is dependent on how you talk and that you talk (§75). You learn what matters in art only retrospectively (§76); that you care about art is shown in what you do but mostly in that you know it is never ultimately up to you (§77). There is no one right way to talk about art (§§78–79). You can make mistakes and learn from your mistakes (§80). Ways of talking include nervous list making (§§81–82), and the grand survey (§82). But no way of talking, no particular emphasis, is the sure sign of true knowledge (§83). That you have been somewhere is not shown by how you talk, and the fact that art matters to you doesn't mean that you have been anywhere (§§84–85). Thus list making may express care (§85). Art is something you are introduced to, and the questions you ask (§86, §89). Just as there is no one way of talking about art, so there is no one way of being introduced to it (§87), though of course there are bad introductions (§88), even if you don't learn that they are bad from any reaction in what is being introduced to you (§89). Introduction is a ceremony (§90), and one where it is hard to say what counts as reciprocating in kind (§91), which is why you are often told that you should just leave art be (§92). Art etiquette is not like a local ordinance or like the consequence of your pretending anything (§93), for example, of pretending that what you are introduced to can reciprocate (§94). Regarding consequences of the questions you ask upon introduction (§95), you never find out that something is after all anything else (§96). The argument is recapitulated after "The Walrus and the Carpenter" (§§97–101):

Could introduction, or could talk, be a trick (§99)? Talk may be part of a trick, but there is nothing tricky (§100) or nonsensical about talk (§101). What you say is no placeholder for your ulterior motives (§102), though you often address art by promising to talk about certain things. And you correct your talk independently from any reactions of the talked-about furniture (§103).

3. A Mistake (§§104–150)

You introduce and are introduced to things remonstrant and unremonstrant. Art-things are unremonstrant, but not all things unremonstrant are art-things (§104). You learn to correct introductions of unremonstrant things (§105), and disagreements about how to introduce a quintet are not a special kind of disagreement. Art-talk is not special talk. To learn to art-talk you need only to know how to correct introductions of unremonstrating stuff. And still there are no experiments you can conduct (§106). You do not vote about art (§107), nor do you really consult (§108), and you certainly don't decide what anything *is* by vote or consultation (§109). Nor are preferences expressed over time like a vote, since there really is nothing to decide (§110). Art-talk is a series of asynchronous preferences expressed over time, though not a game, since there is no decision as to who wins (§112). It is like the Caucus-race, but it doesn't seem to have a point (§113). Art-talk may resemble many things: voting, consulting, the Caucus-race, and a pointless Caucus-race (§114). All talk about a quintet has in common that you talk about the quintet. But this is not saying much, since no nontalked-about thing can be used to arbitrate between talk. Pointing to the quintet is also talking about it (§115). Also, talking about the quintet is not doing one same thing: participants often have different goals. They may look like they're doing the same thing, but looking at what they do is not enough to determine their goals (§116). Art-talk is similar to the Caucus-race in that the participants can enter and leave the race at will. They have likings. Does this mean that you run only insofar as you like it (§117)? If it were so, everything would be entirely up to you, and art-talk would just be what happens to you only because you like art (§118). Also, since you vouch for yourself, you always win (§119). Vouching for yourself is not vouching: it's what everyone does (§120). If you always win against yourself, you always lose (§121). The analysis of this mistake (§§122–123) entails the analysis of the belief that you can be judge-and-jury about your likings (§123). Could you ever have a fair trial (§124), have respectable motives for going to court, in matters of art (§125)? Though you often hope for a court-like decision in matters of art (§126), no court will be of any help, also because no injustice has been committed (§127). Two sides of the same mistake are imagining that you are judge-and-jury and imagining that a better court would help (§128). Regarding what an art-court would be like (§129), you deplore art-related occurrences like you deplore the stealing of something in front of you (§130), and your description will often argue for direct access to what has been stolen as evidence of the stealing (§131). In art-court you always express impa-

tience with courts (§132), and this gives it a Caucus-race aspect (§133): each participant is trying to do justice to what, for her or him, seems to be the point of the trial, and to oppose every other participant (§134). An art-court is not a court, and no sentence is to be expected in matters of art (§135); this doesn't mean art-talk is mad. It means art-talk is no game, race, or matter for the courts (§136), and so art-talkers are not people mad in similar ways (§137), or mad because they have all been doing certain things. Art-talk requires that you approach people doing certain things and talking in certain ways (§138), though it is never like being anywhere (§139). Choreographic inspection of actions will not sufficiently describe art-talk, and art-talk often has to distinguish between what will look like identical actions. It requires that you approach art-talkers (§140), though this does not mean moving closer to anything or anyone. There are many ways of approaching people (§141). Is there a right spirit for approaching people? Even if there were, you could still be judge-and-jury about the spirit (§142). Being judge-and-jury, or hoping for a court decision, is not a function of being somewhere (§143). You approach other people when you hope for more than your likings (§144), and this can be expressed in many ways (§145). You can describe it as having been to school, but what is relevant to having been to school is that you "take in" other people "like a picture" (§146); this cannot be certified (§147), since what you would call knowledge here would not be an independent part of that picture (§148), and this is why you will often have to describe a "whole scene" rather than an isolated object (§149): this whole scene is a bit of your life, and the only necessary ingredient to it is you. You are not judge-and-jury about the fact that you are you (§150).

4. What Happens (§§151–199)

Whatever happens with art is not content but that it happens to you (§151). Talking about art is not talking about what happens anyway (§152) and need not entail any report on what happened to you (§153). What happens can be shown in many ways: how you talk about yourself, how you talk about what has happened, and how you talk about a bit of art, and also in that you do not talk at all (§154). When you talk about art, art is not *attached* to you, nor do you have to employ a certain tone or grammar (§155). Art is more like a thought, or like your feet (§156). Art is not like a series of implements you may have about yourself (§157) but, rather, like an aggregate of thoughts, feelings, beliefs, and implements undetachable from a person; art is "so-around" a person (§158). You should not confuse the fact that what counts as art may change over time with the fact that something is so-around you, like a thought. You develop art like a thought (§159). Could art-talk not be talk (§160)? Art-talk as "sending presents to one's own feet," honoring something so-around you (§161). You often say that art has turned you into a different person (§162), express that in many ways (§163), and may even believe that describing it would be placing an emphasis on the wrong note (§164). Alice describes who she was yesterday as being a different person (§165), and you often do it to suggest that you are not responsible for some of your

actions (§166). But when you describe that different person, your former self is still your own (§167), despite the fact that you want to describe yourself as something that happened to someone else, which you can't do (§168). Like Alice, you may remember feeling "a little different" (§169), and you may imagine that you have been changed into someone else, perhaps because of art (§170). Perhaps you can ascertain whether you are yourself experimentally (§171) and devise some test (§172). However, there is no test to determine that you are who you are, since there is no test for what is so-around you (§173). When you say that you have changed, you usually intimate psychological causes—that you remember something (§174); but that something happens to you does not mean that you need to become someone else—you may just feel "a little different" (§175). Feeling "a little different" is no feeling that you can identify. You will sometimes say instead that something art-related has happened to you (§176). What happens intimates a description of who you are, but 'Who are you?' is not a useful question (§177). When something happens to you, what changes is not that you become someone else as that the list of what is so-around you changes (§178); this need not entail any exception to the laws of nature (§179). 'Who are you?' questions typically produce 'What are you?' answers. You cannot explain that you are who you are (§180); often you will "tell adventures"; telling adventures requires that you get close to other creatures (§181), and when you are told adventures, you are never explained what you understand. Adventures are descriptions of changes in what is so-around someone (§182); they deflect 'What are you?' questions into 'Where are you?' questions. Adventures tell where you are, where in the world you are (§183). The world is where you are, and if art is so-around you, then art is where you are, so-around you (§184). Some people will tell where they are by telling art-adventures, but there are many other ways of doing so (§185). When art—or bits of art—is lost, what is lost is something so-around; you lose art like you lose beliefs (§186), not like you lose a person (§187). The idea that you talk about art because you fear it has been lost (§188), and the idea that telling adventures is the consequence of something's having been lost versus the idea that telling adventures is responding to someone else asking where you are by saying that something happened (§189). Art-talk and the notion that something happened to you, responding to 'Where are you?,' though not by *explaining* where you are. Others recognize where you are relative to art when they no longer see art as a possible belief, a course of action, or a custom (§190). Sending presents to your own feet is not an emotion (§191) or a cultural practice (§192). Art looks over-there when you talk about it; that you talk about it suggests it isn't. That you send it presents takes precedence over the presents sent (§193). The present-sending does not produce incremental knowledge (§194). A simpler version (§195) cannot explain the most important things about art-talk (§196). Art-talk is not a cooperative process based on agreement and is not a form of debate (§197). It is more like people singing in a choir, and like when they are not singing, and like when they are telling adventures; it is not like agreeing on propositions (§198). What art is like (§199).

Index of Citations

Citations in the text are identified by double inverted commas. The format of the index is section number in the text, W or L for *Wonderland* or *Through the Looking-Glass,* and chapter number and page number, in Donald J. Gray, ed., *Alice in Wonderland: Authoritative Texts of* Alice's Adventures in Wonderland, Through the Looking-Glass . . . *Second Edition* (New York: Norton, 1992). Some of the more direct allusions have also been included in this index.

Acknowledgments

The National Humanities Center and the Rockefeller Foundation have given the author a year of unencumbered peace. The University of Lisbon and the University of Chicago have allowed him to experiment with some of his ideas and, afterward, to go away for a year.

Index

Numbers refer to numbered sections (§§). Double quotation marks indicate phrases from the Alice books. Single-quotes indicate other technical terms.